IMAGES
of America

BLUE EARTH COUNTY
MINNESOTA

# IMAGES of America
# BLUE EARTH COUNTY
## MINNESOTA

Blue Earth County Historical Society

ARCADIA

Copyright © 2000 by Blue Earth County Historical Society.
ISBN 0-7385-0830-6

Published by Arcadia Publishing,
an imprint of Tempus Publishing, Inc.
3047 N. Lincoln Ave., Suite 410
Chicago, IL 60657

Printed in Great Britain.

Library of Congress Catalog Card Number: 00-109664

For all general information contact Arcadia Publishing at:
Telephone 843-853-2070
Fax 843-853-0044
E-Mail sales@arcadiapublishing.com

For customer service and orders:
Toll-Free 1-888-313-2665

Visit us on the internet at http://www.arcadiapublishing.com

*Cover Image*: Featured on our front cover is an unusual double-wedding photograph from the year 1896. Eva and Augusta, daughters of Mr. and Mrs. Charles Johnson of Judson, were married on November 5th at the Johnson farm. Most of the 130 family and friends who attended are in the photo. Eva married Peter Danielson and they moved to Winthrop, where Peter was in business. A short four years later, the young bride passed away leaving her husband and three young children. Augusta married James Anderson and remained in Judson, where they rented the family farm. The couple had four children and later divorced.

# Contents

Acknowledgments 6

Introduction 7

1. The Northeast 9
   The Townships of Lime, LeRay, Jamestown, Decoria, and McPherson

2. The Southeast 31
   The Townships of Beauford, Medo, Mapleton, and Danville

3. The Southwest 53
   The Township of Lyra, Sterling, Shelby, Pleasant Mound, Vernon Center, and Ceresco.

4. The Northwest 71
   The Townships of Butternut Valley, Cambria, Garden City, Judson, Lincoln, Rapidan, and South Bend

5. Mankato and North Mankato 95

# ACKNOWLEDGMENTS

The Blue Earth County Historical Society (BECHS) is pleased to take part in the *Images of America* series. Like many of the tasks taken on by our historical society, this one would not have been possible without our dedicated volunteers. BECHS wishes to sincerely thank the Publications Committee for their efforts in putting together this photographic history of Blue Earth County. Without their dedication and seemingly endless hours of work, this publication would not have gone beyond the idea stage.

The Blue Earth County Historical Society Board of Trustees would like to acknowledge the people who assisted in the production of this book.

Shirley and Win Grundmeier and Jo Schultz began assembling the people who would canvass the county searching for previously unpublished photographs.

Those who volunteered to help collect photos are: Mickey Adams, Harriet Bonnett, Inella Burns, Gerald Frederick, Mike Frederick, Margaret Ganzel, Dolores Greeley, Shirley Grundmeier, Win Grundmeier, Kathryn Hanson, Edith Herzberg, Edith Hopman, Reve Krengel, Carol More, Shirley Schaub, Jane Tarjeson, Myrtle Westphal, and Lorraine Wright.

The photos were organized and the captions researched and written by Inella Burns, Kathryn Hanson Shirley Grundmeier, Jo Schultz, Julie Schrader, Lorraine Wright, and Beth Zimmer.

Special thanks to Jo Schultz and Julie Schrader for the generous amount of time spent working on the final layout and typing up all of the captions.

The staff of the Blue Earth County Historical Society, Archives-Librarian Carol Oney, and Executive Director James Lundgren also worked quite a bit in the research and organization of the book project.

The Blue Earth County Historical Society volunteers are a tremendous group of people who greatly improve our ability to preserve the history of Blue Earth County for today and tomorrow.

# Introduction

This publication deals with the varied and vibrant history of Blue Earth County. Blue Earth County is situated in Southern Minnesota on the big bend in the Minnesota River. The name "Blue Earth" derives from the Dakota name for one of the rivers in the area. The Dakota word is *Mahkato* and refers to the bluish-colored earth that early explorers once believed to contain copper. Early settlers named their county seat from this word, altering to it Mankato.

The land that became Blue Earth County was first occupied by the Dakota Indians. It was opened to white settlement following the United States Government's ratification of the 1851 Treaty of Traverse des Sioux. In 1852, the first settlers arrived. Less than five years later most of the fertile open land in the county was being tilled. The big woods that ran through part of the county disappeared acre by acre as more land was cleared for farming.

The Minnesota River served as the main entry point for Blue Earth County. Steamboats brought supplies and people up the river. At the height of steamboat traffic in 1859, 410 steamboat dockings were made in Mankato. In 1868, the first railroad reached Mankato. While the railroads eventually put an end to the steamboat traffic on the Minnesota, they aided in the development of inland villages by speeding up the transportation of vital goods.

This *Images of America* book will tell the story of the first 70 years of Blue Earth County. From the 1850s through the 1910s, this area went from native-occupied land to an agricultural society. Farms and small villages flourished during this developmental period. Some still exist with a handful of houses and a business or two, while others have disappeared from the map. The images of the people and places of the past have been preserved in the collections of the Blue Earth County Historical Society. Most of the pictures presented here came from those archives. The rest were generously loaned to the Society for inclusion in this book.

The Research Center at the Blue Earth County Historical Society holds thousands of research materials. The book committee did many hours of research for the captions of the photos. The research center is open to the public for both genealogical and historical research. The publications committee hopes that you enjoy these images and that they allow you to better appreciate the history of Blue Earth County and its people.

# One
# THE NORTHEAST

## THE TOWNSHIPS OF LIME, LERAY, JAMESTOWN, DECORIA, AND MCPHERSON

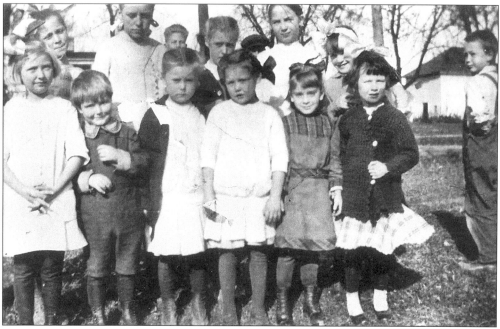

Shown here are the lower elementary students of Madison Lake Public School, 1917. Pictured from, left to right, are as follows: (front row) Helen Wirig, Bobbie Wirig, Bertha Schippel, Evelyn Oney, Lucetta Culp, and Bonnie Allyn; (back row) Elva Dixon, the Schippel sisters, Ronald Wirig (between sisters), Florence Beardsley, and Jessie Culp. The boy on the right is Ray Dahlman. (Photo courtesy of BECHS.)

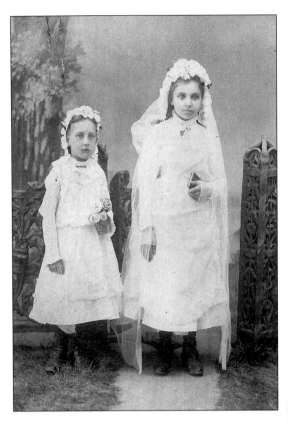

This photograph was taken on Frances Wagner's (right) first communion, c. 1886. Frances is pictured here with one of her younger sisters. The Wagner family lived in Lime Township. On February 13, 1900, Frances married George Hiniker. They had nine children: Marie, Clara, Lucie, Henry, Robert, Edith, Kenneth, Helen, and Anna. (Photo courtesy of Florence Guentzel Hiniker.)

Lillian Doris Miller poses in 1910 with her fur muff and stole. On June 21, 1916, she married Edward Boehland and lived in Lime Township. Lillian died in 1993 at the age of 102 years. (Photo courtesy of Harriet W. Tilman.)

Henrietta Wandersee and Edward Guentzel were married on May 2, 1916, and lived in Lime Township. (Photo courtesy of Florence Guentzel Hiniker.)

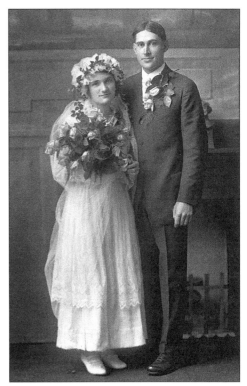

The wedding of Frank Boehland and Irene Guentzel in June 1905, was held at Frank's farm in Lime Township. (Photo courtesy of Harriet Tilman.)

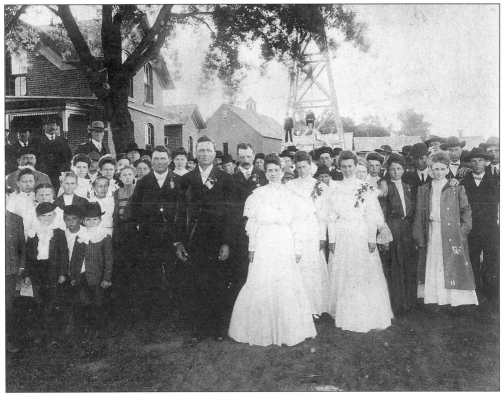

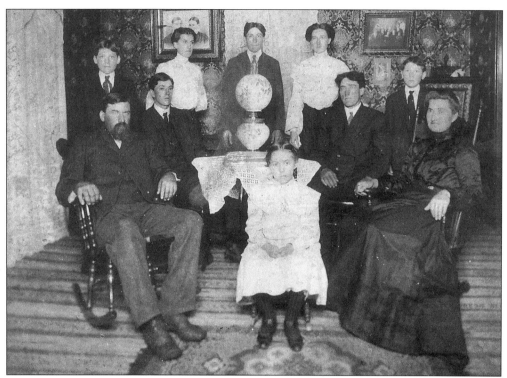

Pictured here are Fred and Caroline Guentzel and their family. The photograph was taken in their farm home in Lime Township, c. 1900. (Photo courtesy of Florence Guentzel Hiniker.)

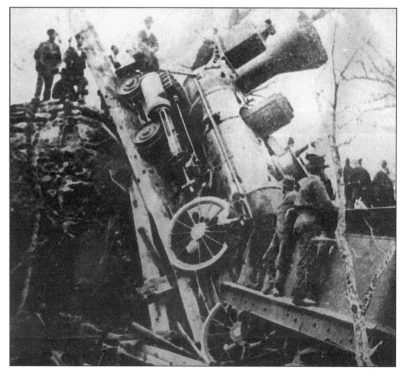

A train wreck at Bradley's Crossing occurred on April 18, 1875, when the Omaha Railroad engine fell as the railroad tracks collapsed. Bradley was a railway station and post office on the Chicago, St. Paul, Minneapolis, and Omaha Railway. It was located 4 miles north of Mankato in Lime Township. (Photo courtesy of BECHS.)

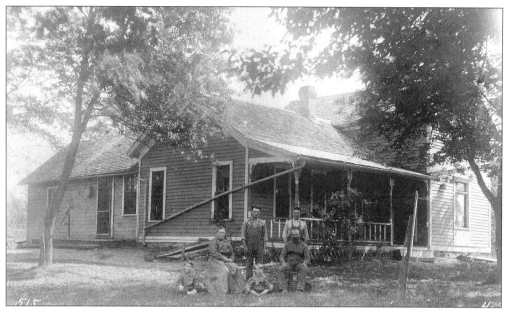

Above is a photograph of the Vincent Sieberg farm in LeRay Township, c. 1910. The family is pictured here, from left to right, as follows: (seated) Andrew, Ernie, Rose, and Joe; (standing) Leo and Charles. (Photo courtesy of Curt and Adeline Sieberg.)

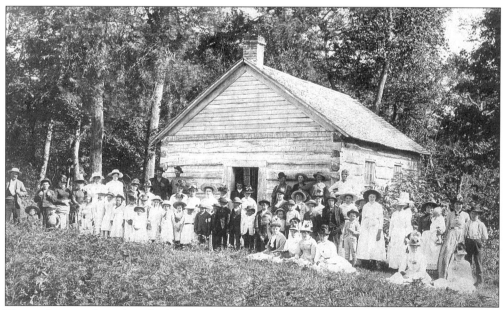

This gathering of pupils and adults at the old log school in LeRay Township was taken at the turn of the century. (Photo courtesy of Myrtle Westphal.)

This photograph was taken following the funeral of Nick Frederick Sr. in 1910 at LeRay Township. Pictured, from left to right, are as follows: Steve, John, Joe, Nick, and Pete Frederick. Note the boy looking out the window. (Photo courtesy of Jerry Frederick.)

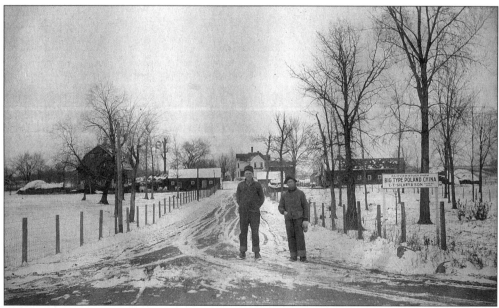

L.T. Silkey and his son, Fred, owned the Fairview Stock Farm in LeRay Township. Shown in this photo (c. 1910) are hired hand August Westphal and Fred Silkey. L.T. Silkey lived on this farm for 63 years and was one of the prominent purebred Poland China hog raisers in Minnesota. (Photo courtesy of Myrtle Westphal.)

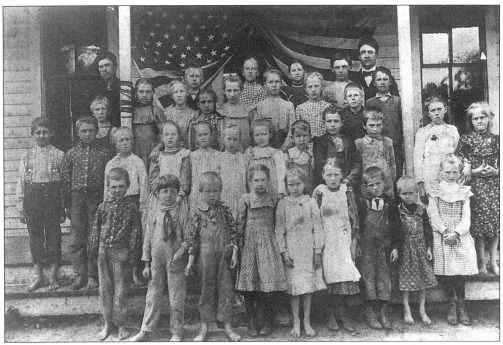

Teacher Herman Panzram poses with his pupils in front of the Nyquist School in the spring of 1904. The Nyquist School (or District #135) was located in Section 24 in LeRay Township. Country schools generally took on the name of the landowner near the school. Note the handsome American flag and the barefoot children. (Photo courtesy of BECHS.)

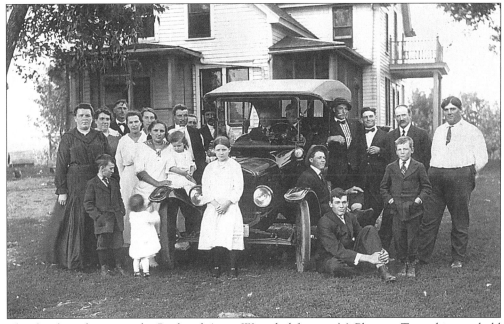

This family gathering at the Paul and Anna Westphal farm in McPherson Township was held just before their son Walter entered military service on June 28, 1918. The 1917 Ford Model-T touring car was owned by Walter Tolzmann. (Photo courtesy of Myrtle Westphal.)

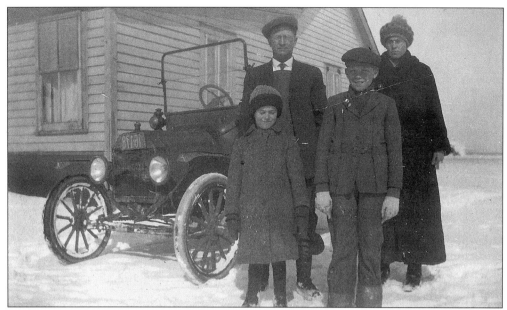

William and Annie (Krause) Silkey shown with their children Walter (left) and Elmer (right) in front of their 1915 Model-T Ford touring car. (Photo courtesy of Myrtle Westphal.)

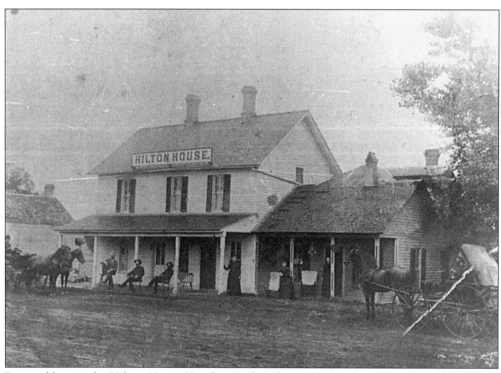

Pictured here is the Hilton House Hotel in Eagle Lake, c. 1880. (Photo courtesy of BECHS.)

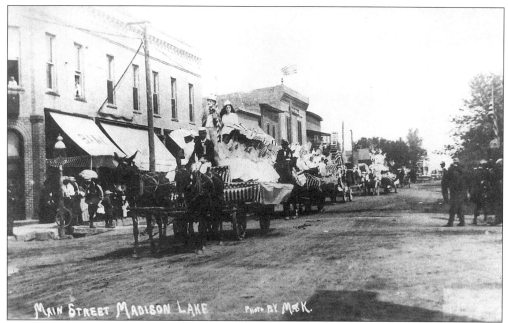

These horse-drawn floats at the 4th of July parade in Madison Lake are decorated with bunting. This picture was taken before 1910 when four blocks of the town were destroyed by fire. The large building on the left was the bank with the Opera House upstairs. (Photo courtesy of Madison Lake Area Historical Society.)

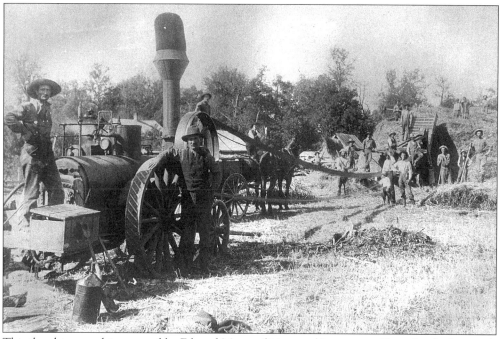

This threshing machine owned by Edward Mann of Lime and Jamestown Township had a wood-burning engine with a spark catcher. This was fortunate as threshing machines without the device frequently started fires. (Photo courtesy of Madison Lake Area Historical Society.)

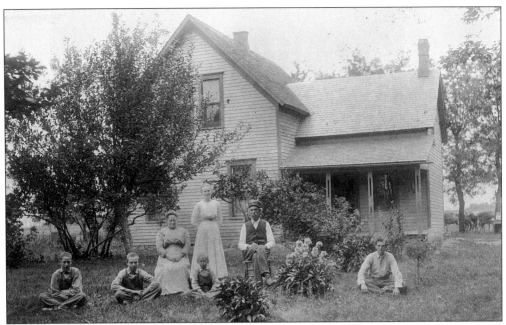

Pictured are James and Ellen Connor and family at their Jamestown Township farm in 1904. (Photo courtesy of Ann Connor Frederick.)

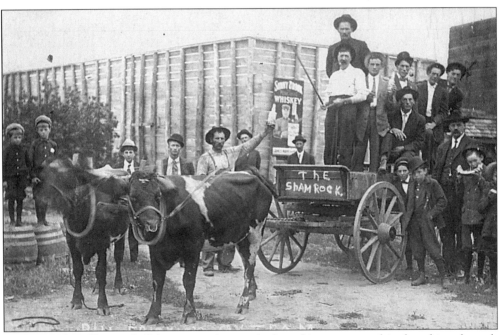

Madison Lake's Shamrock Saloon was advertised when this oxcart was hired to drive through town. Jim Mape (owner of the saloon is in the wagon wearing the white shirt) bought watermelons for the kids. The big icehouse in the background was a necessity for every saloon in those days. Ice cakes were harvested and packed in sawdust, which was plentiful from the many saw mills around town. (Photo courtesy of Madison Lake Area Historical Society.)

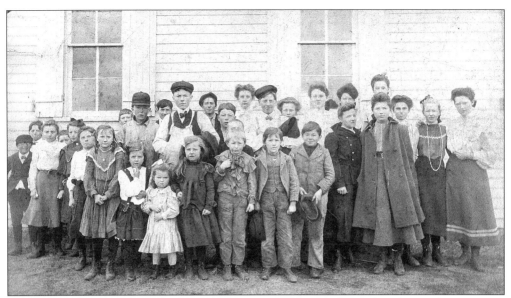

District #133, organized in 1878 in Jamestown Township, was located in the northwest corner between sections 25 and 26. The girl in the front row with her hand to her chin is Mary Smith and the boy with his hat in his hand is John Smith. Others in the photo taken *c.* 1900 are Fasnachts, Fosters, Danberrys, and Kopps. (Photo courtesy of Madison Lake Area Historical Society.)

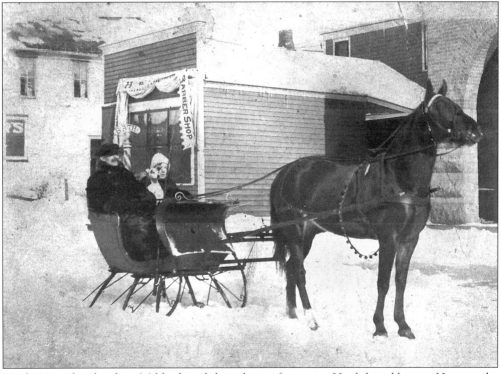

Hank Wirig, his daughter Mildred, and their dog go for a spin. Hank loved horses. He owned a barber shop and served as mayor of Madison Lake. (Photo courtesy of Madison Lake Area Historical Society.)

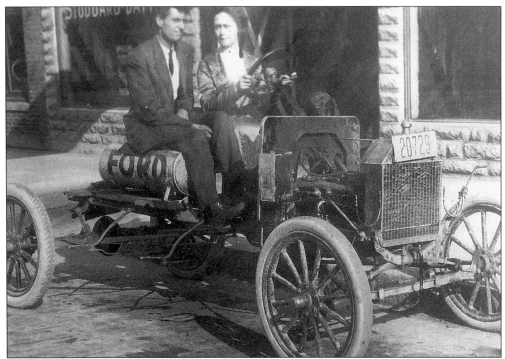

This 1909 photo shows Glen Allyn and his wife Helen in their automobile. Glen was a very good mechanic who met and assisted Charles Lindberg with his airplane when he barnstormed through southern Minnesota. (Photo courtesy of Mike Frederick.)

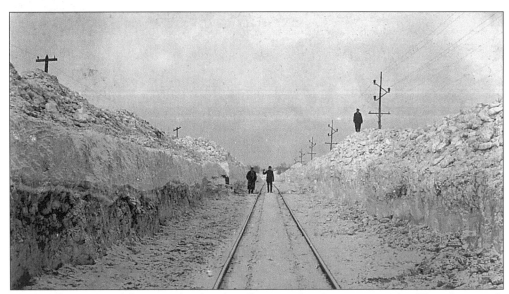

In 1917, heavy snowfalls stopped railroad traffic twice for almost two weeks. This photograph of the Chicago and Great Western Railway track near Madison Lake shows the deep cuts through the snow. On the track are Charles Reinsberg and Leo Mettler. Herman Muellerleile is on the snow bank. (Photo courtesy of Madison Lake Area Historical Society.)

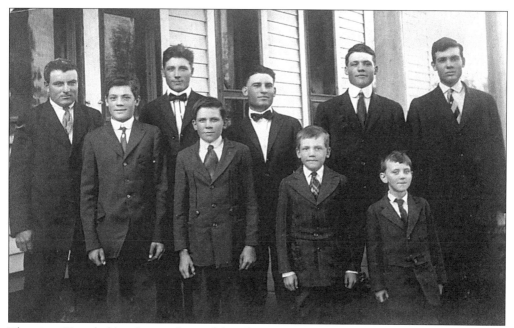

The nine Westphal brothers in front of their home on June 28, 1918, are pictured, from left to right: (front) Emil, William, John, and Paul; (back) Reinhardt, Walter, Arthur, August, and Otto. (Photo courtesy of Myrtle Westphal.)

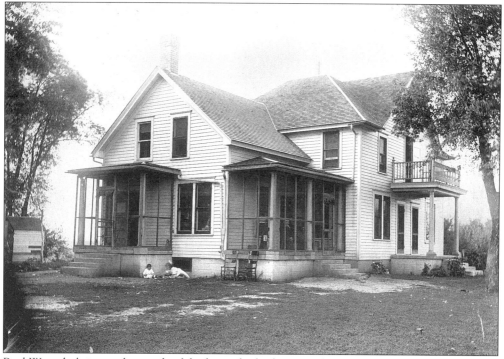

Paul Westphal sits on the porch of the house he built in McPherson Township, c. 1915. (Photo courtesy of Myrtle Westphal.)

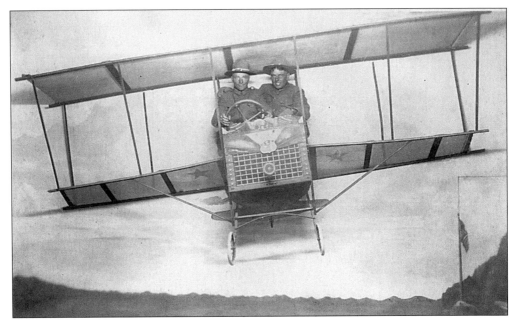
Walter Westphal and his friend in Army uniforms anticipate active duty in the Air Corps by posing in a mock-up biplane, c. 1918. (Photo courtesy of Myrtle Westphal.)

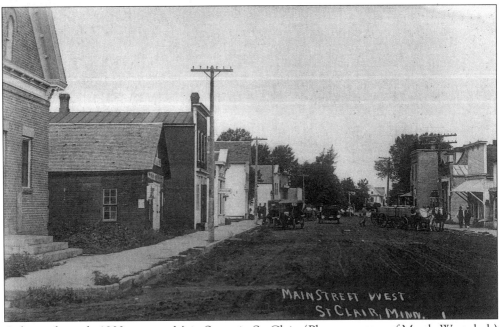
A day in the early 1900s on west Main Street in St. Clair. (Photo courtesy of Myrtle Westphal.)

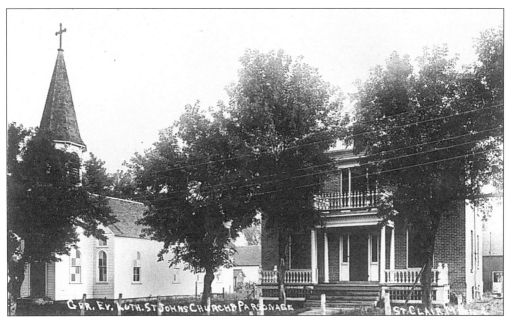

St. John's German Evangelical Lutheran Church and parsonage in St. Clair. The church was built in 1876, the parsonage in 1905. (Photo courtesy of Myrtle Westphal.)

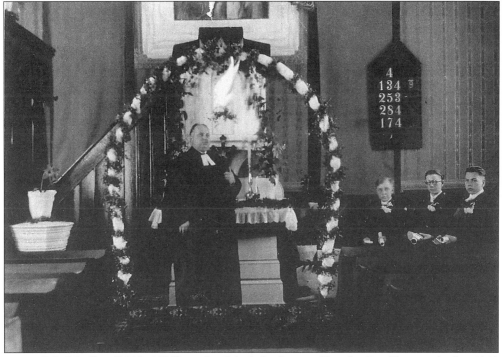

Pastor R.J. Mueller (1913–1920) in St. John's Lutheran Church, St. Clair, with the 1918 confirmation class which included Alvin Schenk, Fred Kruse, and Wally Prochel. (Photo courtesy of Myrtle Westphal.)

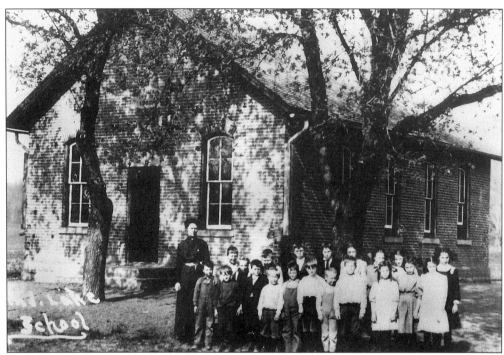

Teacher and children at the Indian Lake School, District #72 pose for their picture on a fine spring day in 1911. The school was located in Section 36 of South Bend Township and remained in use until 1945. (Photo courtesy of BECHS.)

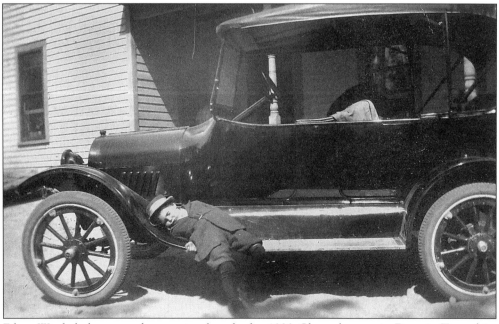

Edgar Wenkel sleeps on the running board of a 1920 Chevrolet car in Decoria Township. (Photo courtesy of Edith Herzberg.)

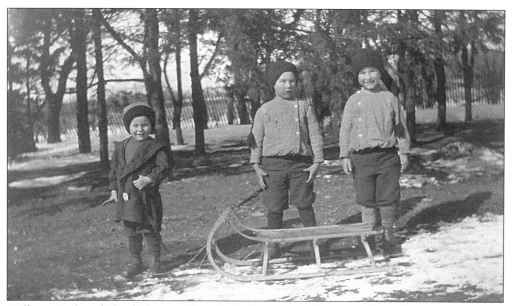

Willmar, Earl, and Floyd Thrun with their sled in Decoria Township. Note the long snow fence in the background. (Photo courtesy of Edith Herzberg.)

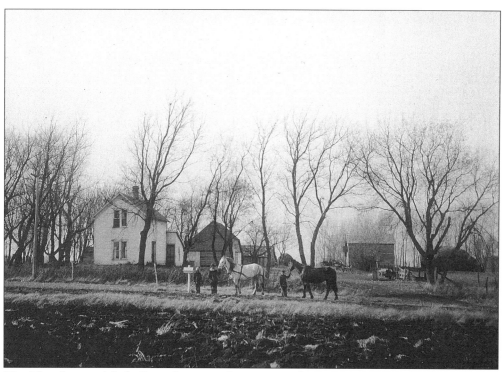

The Theodore and Lulu Franz home in Section 29 of Decoria Township, c. 1918. (Photo courtesy of Edith Herzberg.)

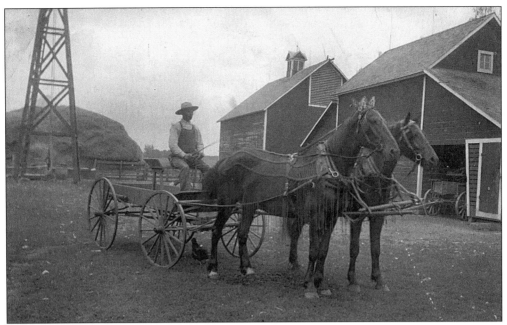

Wilhelm Weber with his team of magnificent horses and farm wagon on his farm in Section 28 in Decoria Township, c. 1895. (Photo courtesy of Edith Herzberg.)

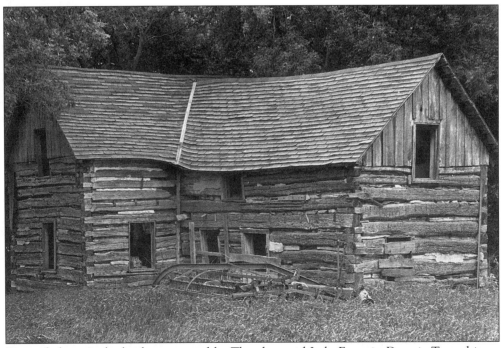

Pictured above is the log home owned by Theodore and Lulu Franz in Decoria Township, c. 1880. Their sons, Harold and Herbert, were born in this log house. (Photo courtesy of Edith Herzberg.)

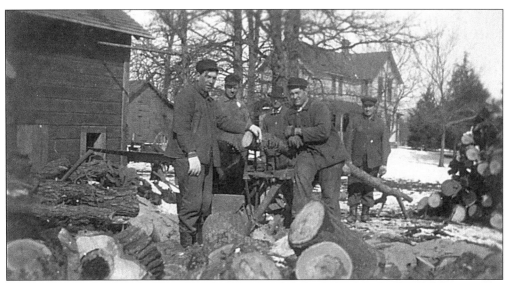

Ernest and Fred Thurn saw wood in Decoria Township in this c. 1900 image. (Photo courtesy of Edith Herzberg.)

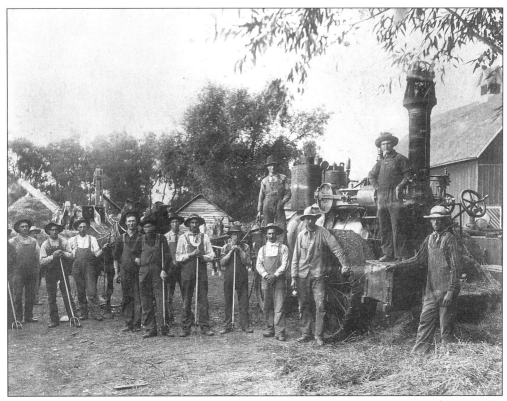

A threshing crew takes time out to pose with their steam tractor in Decoria Township, c. 1910. John Lortz and Albert Weber are on the right. (Photo courtesy of Edith Herzberg.)

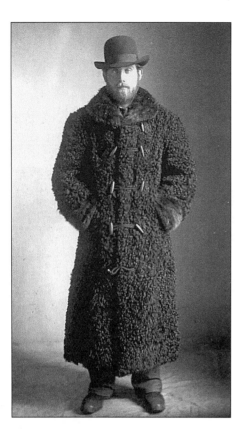

Charlie Weber of Decoria Township models his fur coat, c. 1915. (Photo courtesy of Edith Herzberg.)

Built in the 1860s, this log cabin on Harris Wilder's farm in Decoria Township (on land still owned by the Wilder's) is still standing. This photo, taken c. 1919, shows from left to right: Verna Thrun (Cramer), Edna Thrun (Cords), and Alma Thrun (Marzinske). (Photo courtesy of Edith Herzberg.)

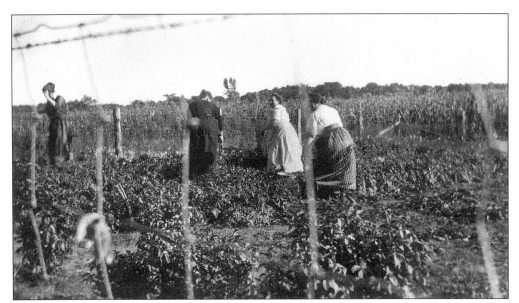
In this photograph, women dig potatoes on Ray Ward's farm in the early 1900s. (Photo courtesy of Edith Herzberg.)

This was August Thrun's residence in Decoria Township. Large families required large houses. (Photo courtesy of BECHS.)

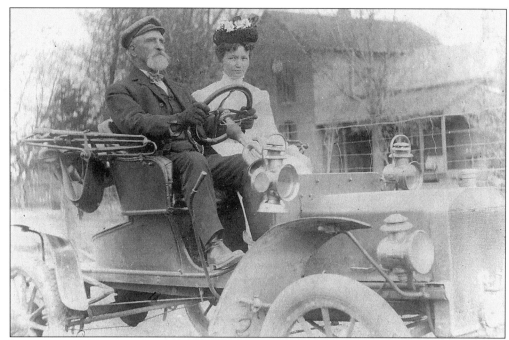
Lawrence and Christine Cummins proudly drive their new car near Mankato. (Photo courtesy of BECHS.)

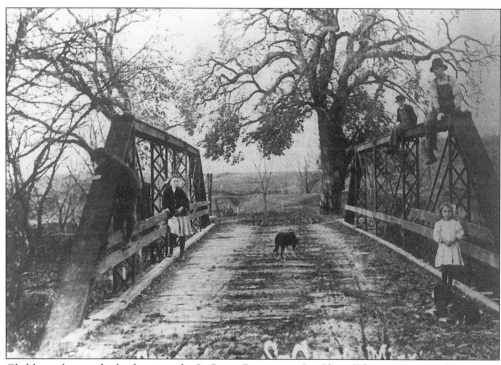
Children play on the bridge over the LeSueur River near St. Clair. (Photo courtesy of BECHS.)

# Two
# THE SOUTHEAST

## THE TOWNSHIPS OF BEAUFORD, MEDO, MAPLETON, AND DANVILLE

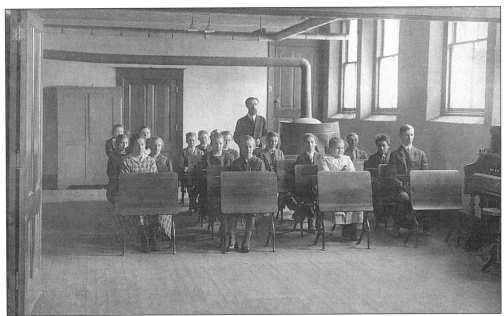

Rural Blue Earth County was littered with country schools. This photo, taken c. 1915, is a typical one-room school with pupils of various ages. Generally, boys didn't go to school very long because they were needed to work on the farm. (Photo courtesy of Reve' Krengel.)

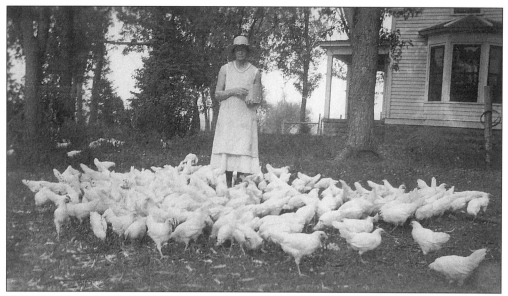

Nell Ward feeds her flock of chickens in this c. 1915 image. (Photo courtesy of Carol More.)

Patrick and Bridget (McCarthy) Howley were Irish immigrants who settled in Beauford Township in 1866. At the age of 25, Patrick purchased 80 acres of land for $3.50 per acre. Patrick and Bridget raised a family of five children on this farm: Roger, Emma, Margaret, George, and Charles. Theirs was just one of many early immigrant families that settled in Blue Earth County. (Photo courtesy of Paul and Doreen Vangerud.)

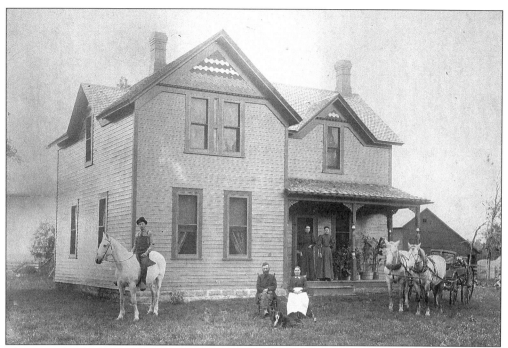

The Oger family from Beauford Township, c. 1880, are pictured, from left to right, as follows: John (on the horse), William, Sarah, Olive, and Clara (married George Sellers). (Photo courtesy of Agnes Sellers.)

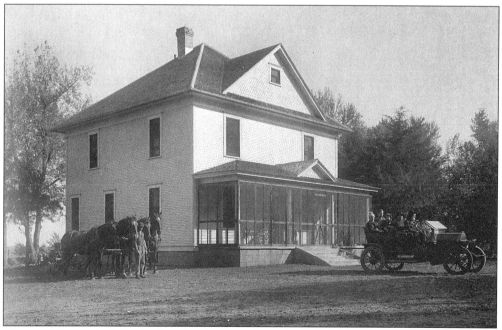

This 1912 home, built by Andrew Little, was a showplace one mile south of Beauford. The car belongs to his daughter Grace and her husband Alec Anderson, who lived in Mankato. (Photo courtesy of Agnes Sellers.)

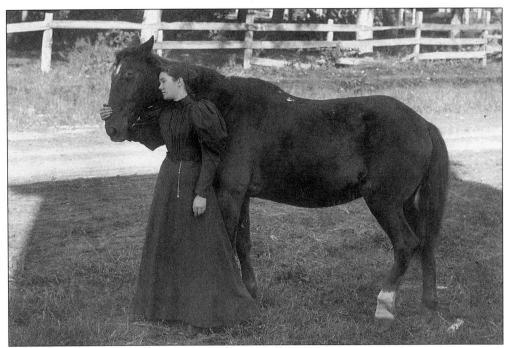

Before she married in 1895, Agnes Little was given her own horse. A women owning her own property was unusual. She rode "Missy" sidesaddle. (Photo courtesy of Agnes Sellers.)

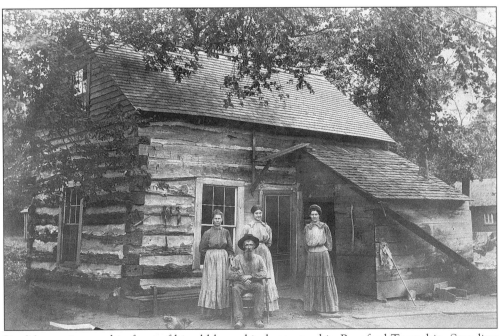

Jim Morrow is seated in front of his old log cabin homestead in Beauford Township. Standing behind him, from left to right, are his wife Hattie and his daughters Hattie and Florence. (Photo courtesy of Agnes Sellers.)

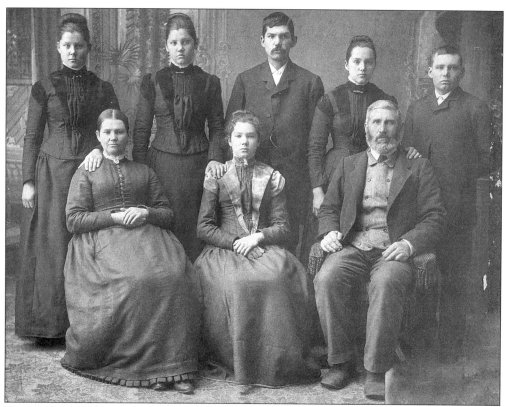

The Andrew Little family of Beauford Township posed for this 1887 Christmas photograph. They are arranged, left to right, as follows: (seated) Euphemia, Agnes (Mrs. Peter Will), and Andrew Little; (standing) Jenny (Mrs. Frank Oachs), Miss Euphemia, John, Grace (Mrs. Alex Anderson), and Tom. (Photo courtesy of Agnes Sellers.)

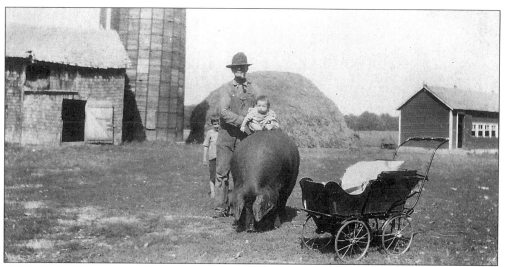

Pete Senesac with son Cletus and daughter Bernadette (Mrs. Edgar Winkel) who is sitting on the large hog. The silo was made of short wooden blocks and was later torn down to make two chicken houses. (Photo courtesy of Edith Herzberg.)

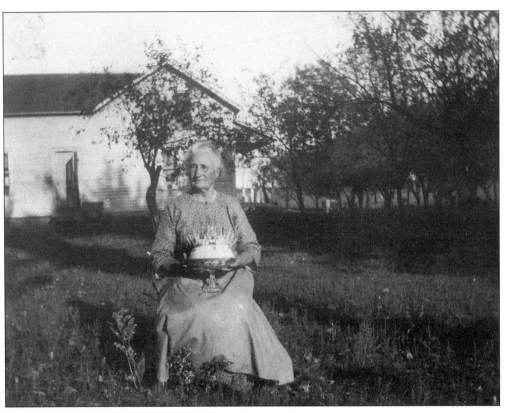

This photograph of Amelia Geger from Beauford Township was taken on her 66th birthday, September 17, 1922. (Photo courtesy of Reve' Krengel.)

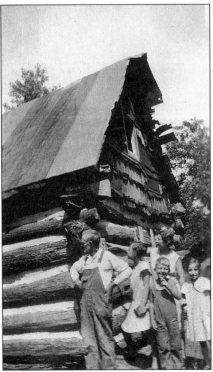

This was Ed and Lizzie Kimpton's old log barn in Beauford Township, c. 1920. Also in the photo are Pete Senesac and his daughter Bernadette. (Photo courtesy of Edith Herzberg.)

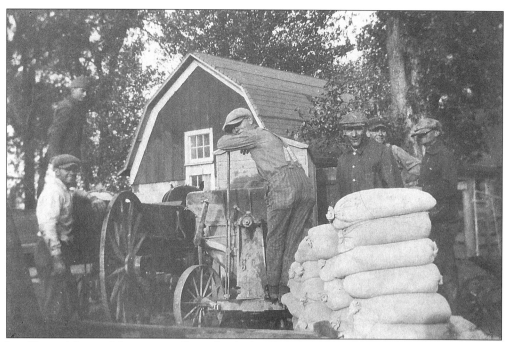

Leo Krengel (center) leans on swill cart by the hog house. Farmers mixed feed by hand for their livestock. Note the sacks of feed on the right. (Photo courtesy of Reve' Krengel.)

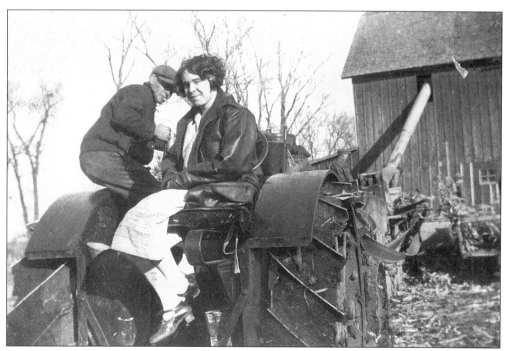

Leo and Leona Krengel are shown shelling corn in this c. 1920 image. (Photo courtesy of Reve' Krengel.)

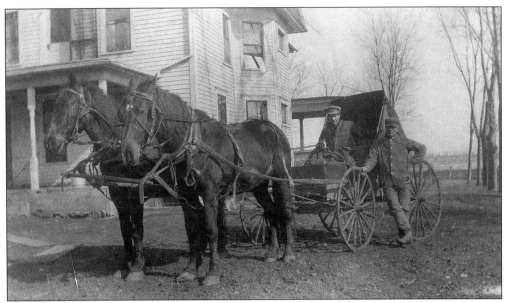
Ray Ward of Mapleton Township sits in his buggy. (Photo courtesy of Carol More.)

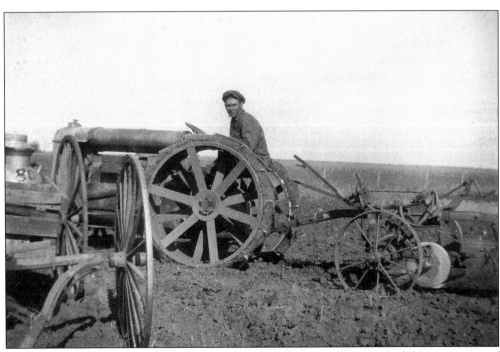
Leo "Chuck" Krengel farms in Beauford Township, Section 17, *c.* 1918. (Photo courtesy of Reve' Krengel.)

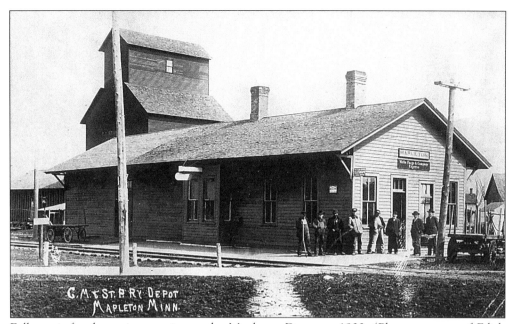
Folks wait for the train to arrive at the Mapleton Depot, c. 1900. (Photo courtesy of Edith Herzberg.)

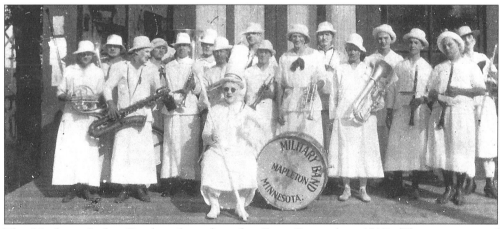
The Mapleton Ladies Band performed at the Corn Carnival in 1917. (Photo courtesy of BECHS.)

Erected in 1887, Mapleton was proud of its fine high school. (Photo courtesy of Agnes Sellers.)

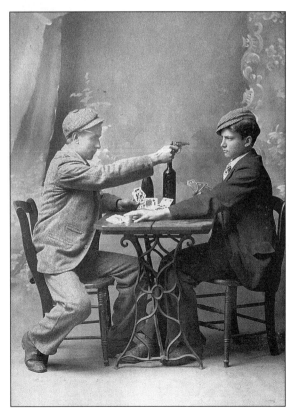

This posed photo by Keene Photographers in Mankato shows William Will (right) of Mapleton and a friend playing cards. In later years, Will—who was one of ten sons in the David Will family—became a doctor. (Photo courtesy of Agnes Sellers.)

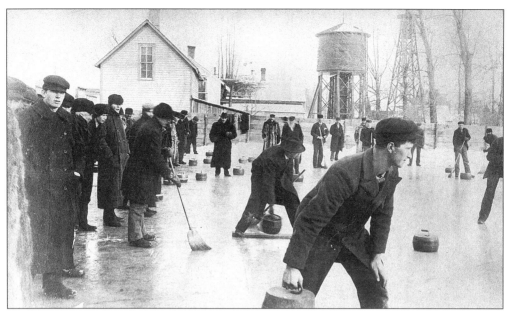

This picture of curling by the local curlers was taken when the game was played on an open rink in Mapleton. The curler in the front of the picture with stone in hand is John Sharp from Smith Mill.

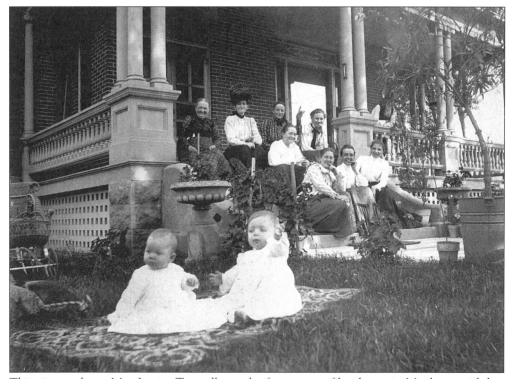

This picture shows Mrs. Louisa Troendle on the front steps of her home in Mapleton with her family, c. 1900. Today this house is an antique shop and tea room called Solie's Castle. (Photo courtesy of BECHS.)

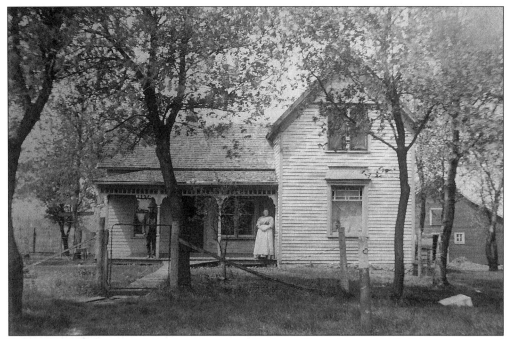

The Amel and Amy Goodrich farm home in Mapleton Township, c. 1917. (Photo courtesy of BECHS.)

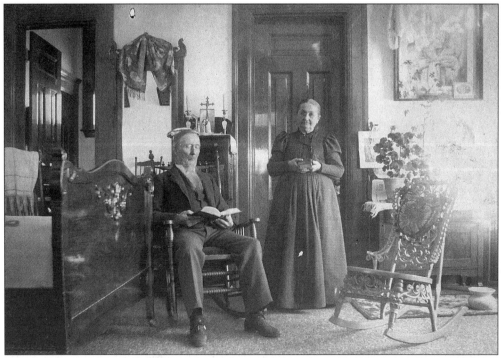

Lucas and Louisa Troendle pose in the bedroom of their home. Their two and one-half-story Queen Anne home was built in 1896; today, it is listed on the National Register of Historic Places. Lucas Troendle owned and operated a general store in Mapleton. (Photo courtesy of BECHS.)

Eight-year-old William McComb of Medo Township sports his Sunday Go-to-Meetin' outfit in 1916. Perhaps his folks, Roy and Anna McComb, had taken him to the restaurant pictured behind him for Sunday dinner. (Photo courtesy of Mary McComb.)

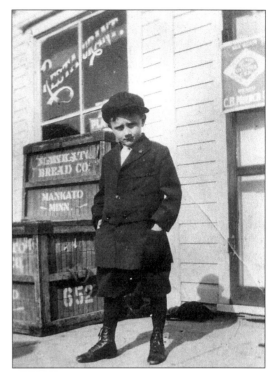

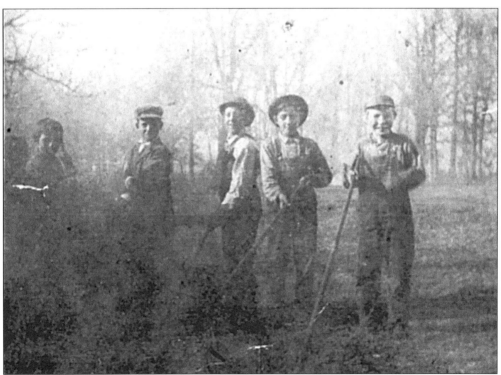

Perch Lake school boys, pictured above in 1909. The three boys on the left are unidentified. John Denn and Richard Schull are on the right. (Photo courtesy of Carol More.)

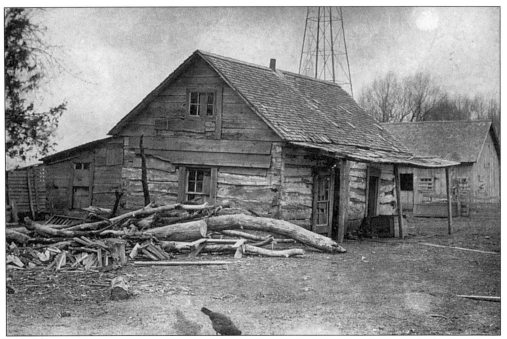

This log cabin was built in Medo Township by Anfin Anderson Ringheim and Ole Ringheim, Norwegian pioneers. Note later additions such as a porch and glass windows and door. (Photo courtesy of BECHS.)

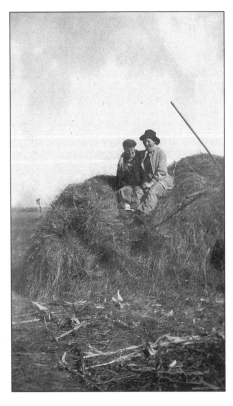

Two girls, Helen and Lucy Burnell, sit on top of a haystack in Medo Township. (Photo courtesy of Carol More.)

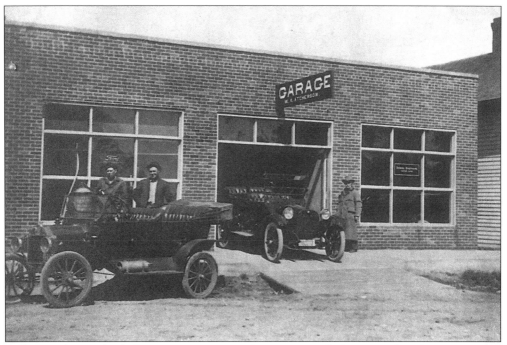

Walter Atcherson built this new garage in Pemberton in 1916. His repair shop was equipped to service both Ford and Dodge gasoline buggies. Pictured, from left to right, are: Rufus Dittburner, Walter Atcherson, and Frank Atcherson. (Photo courtesy of Carol More.)

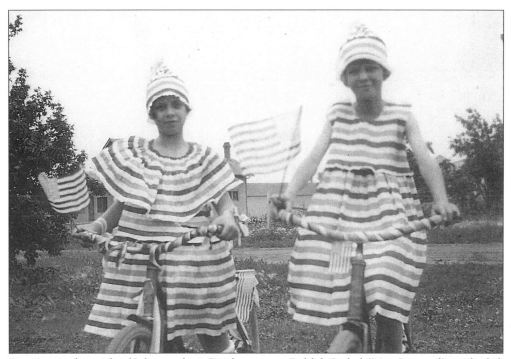

Dressing up for a 4th of July parade in Pemberton are Delilah Pickel (Mrs. Bongard) on the left and Joyous Guddal (Mrs. Casey Clausen) on the right, c. 1920. (Photo courtesy of Carol More.)

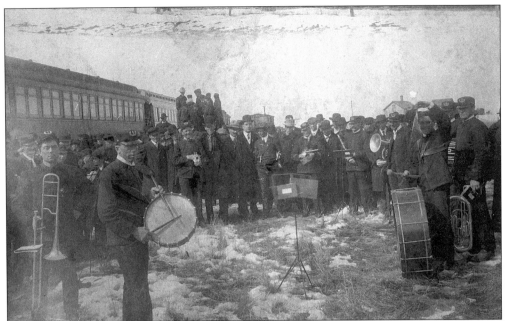

The coming of the first train to Cream, on January 27, 1907, was a big event for the Alphabet Railroad and reason for celebration. George Krouss was the director of the band. In the front, far left, holding a trombone is Ira Southwick and standing at the far right with the French horn is John Foley. Later in 1907, land was purchased just a mile northwest of Cream to build a depot. The rise of this new depot, named Pemberton, caused Cream to fade from existence. (Photo courtesy of BECHS.)

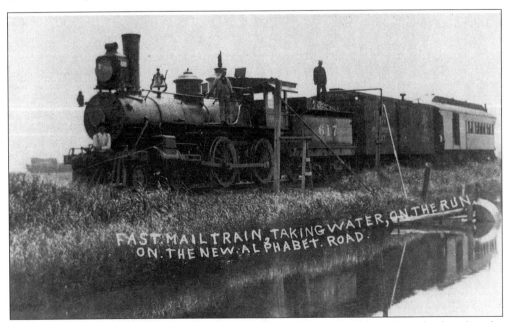

This fast mail-train ran on the Alphabet Railroad line. The name derives from the fact that the railroad went through so many towns their names could not all be listed. In this photograph the engine is taking on water from a lake along the route. (Photo courtesy of BECHS.)

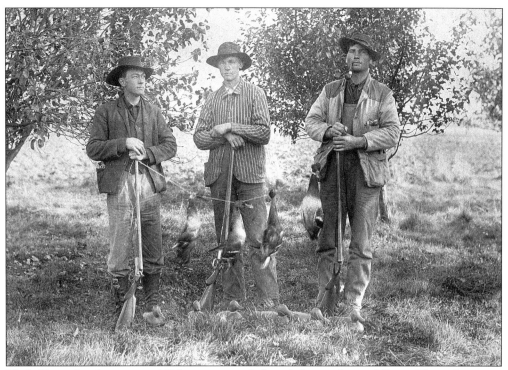

Medo Township hunters, c. 1905, are pictured, from left to right, as follows: Elmer Severson, Mr. Dickinson, and unidentified. (Photo courtesy of BECHS.)

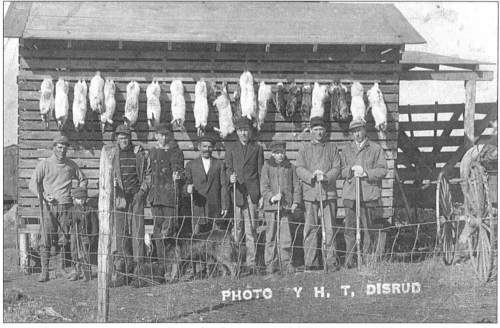

A 1911 hunting party in Medo Township has a successful day eliminating "varmints." Note the small boy at the left with his own toy shotgun. (Photo courtesy of BECHS.)

Carl Schull and Mary Birr were married in 1897 at Redeemer Lutheran Church of Decoria. They farmed in Medo Township near Perch Lake. (Photo courtesy of Carol More.)

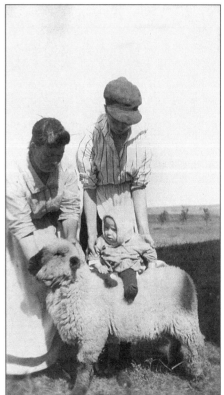

Lawrence More is the baby sitting on the sheep as his mother Maud Burnell More and grandmother look on, c. 1919. (Photo courtesy of Carol More.)

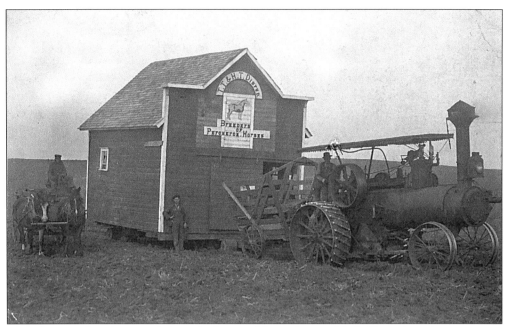

This photograph, taken in 1912 on the Leonard Beise farm in Medo Township, shows a straw-burning steam tractor pulling a horse shed to a new location. (Photo courtesy of BECHS.)

Faye More has his "penny picture" taken in 1912. A handsome 16 year old! (Photo courtesy of Carol More.)

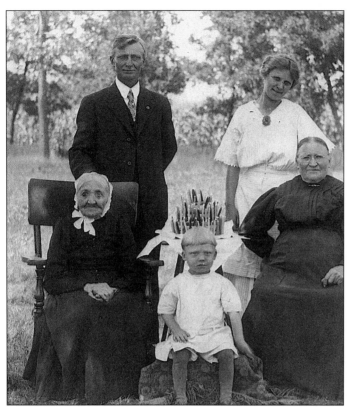

The Guddal family is pictured in 1914 at the 100th birthday celebration of Anna Svensdotter. The party is shown, from left to right, as follows: (seated) Anna Svensdotter (100 years old), Vernon Anderson, and Raghneld Guddal; (standing) Gabriel Guddal and Rachel Anderson.

Mrs. Etta Jones held her son Erwin for this three-generation photograph with Mrs. Phoebe More in 1920. (Photo courtesy of Carol More.)

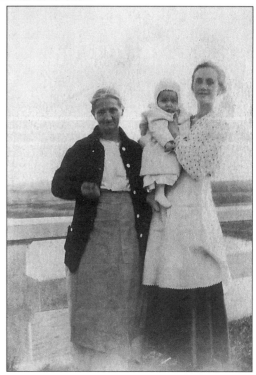

Mary Kraus Laurisch was married to John C. Laurisch. Mr. and Mrs. Laurisch farmed in Danville Township for many years. They were the parents of Frank (farmer), C.J. (attorney), and several daughters. (Photo courtesy of BECHS.)

John C. Laurisch was a veteran of the Civil War and a well-known Danville Township citizen. (Photo courtesy of BECHS.)

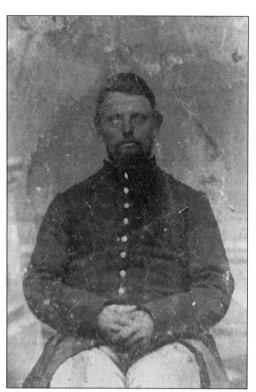

Private Reinhardt Carl Schnepf models his Civil War uniform. (Photo courtesy of BECHS.)

This is Henrietta (Dewitz) Schnepf, wife of Reinhardt from Danville Township. (Photo courtesy of BECHS.)

## *Three*
# THE SOUTHWEST

## THE TOWNSHIPS OF LYRA, STERLING, SHELBY, PLEASANT MOUND, VERNON CENTER, AND CERESCO

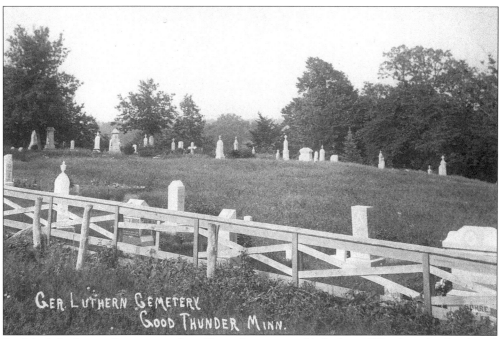

St. John's Lutheran Cemetery in Lyra Township was established in 1877 when the first burial took place. It was dedicated in 1882 by the Evangelical Lutheran St. Johannes Church of Good Thunder. The photograph was taken *c.* 1910. (Photo courtesy of Julie Schrader.)

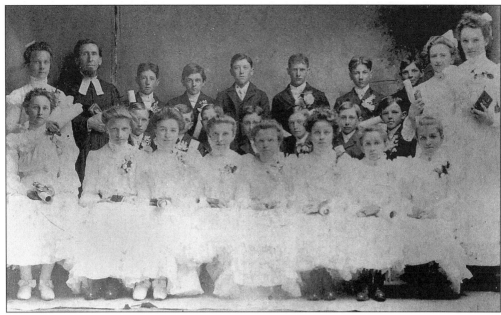

This class from St. John's Lutheran Church was confirmed on April 5, 1903. At this time confirmation classes were taught in the German language. Pictured, from left to right, are as follows: (front row) Lydia Bruscke, Amanda Zuehlke, Olga Wrucke, Anna Heitner, Martha Tischer, Meta Sperlich, Edith Muske, and Martha Nitschke; (middle row) Louis Rosin, unidentified, unidentified, Gust Graf, unidentified, Otto Malzahn, and Arno Malzahn; (back row) Lydia Billet, Rev. John Garbarkewitz, Art Borchardt, Robert Muske, Arno Darge, Carl Rosin, Herman Tischer, Herb Graf, Tillie Meyer, and Emma Kalow. (Photo courtesy of Julie Schrader.)

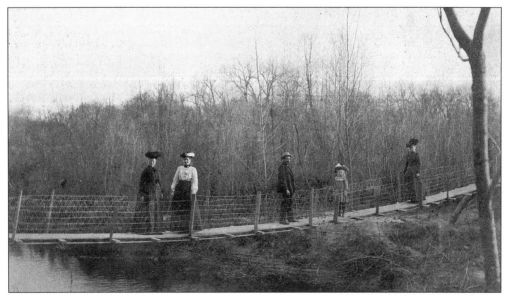

On the swinging bridge over the Maple River, east of Good Thunder, are Grandma Hoeft with Lena Darge and Grandpa Hoeft with Susie Speck. The last lady is unidentified. (Photo courtesy of Delores Greely.)

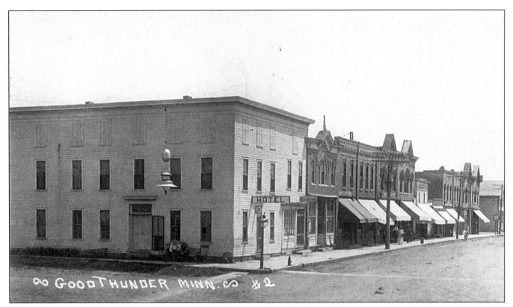

This photo of Good Thunder, c. 1910, shows the Graham House in the forefront. John G. Graham built the three-story frame hotel and hall adjoining his store in 1876. (Photo courtesy of BECHS.)

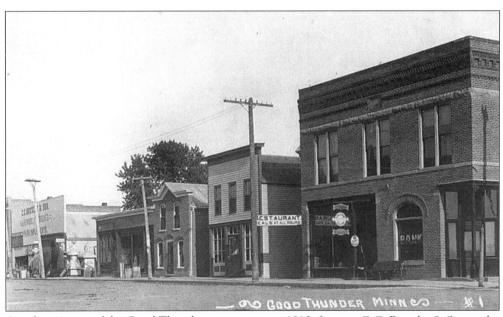

Another picture of the Good Thunder street scene, c. 1910, features C.C. Bruscke & Son at the far left (a hardware store and farm implement) and a restaurant and bank building on the far right. (Photo courtesy of BECHS.)

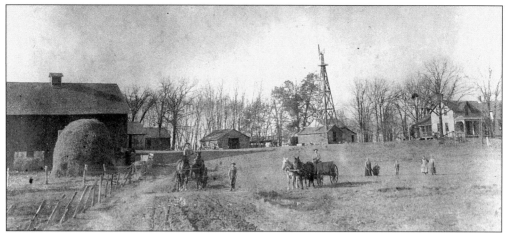

Albert and Bertha (Schultz) Behnke, German immigrants, came to America in 1883. The family came to Blue Earth County, first purchasing land in Decoria Township. In 1903, Albert purchased 160 acres in Section 27 in Lyra Township. Pictured, from left to right, are as follows: Albert Behnke (in wagon), Otto (standing), Frank (in wagon), Bertha with Erna, Emma, Hattie, and Della. The picture was taken in the fall when they were picking corn, c. 1905. (Photo courtesy of Julie Schrader.)

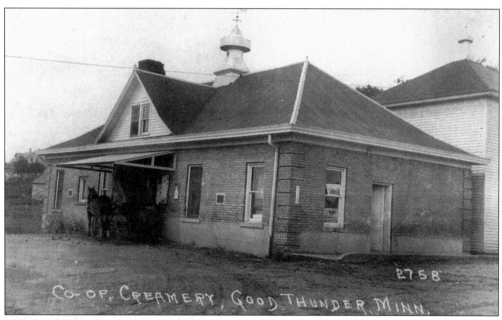

The Good Thunder Creamery, pictured here c. 1895, was located on the east edge of Good Thunder. By the early 1900s Good Thunder had a railroad, grade school, six churches, an express office, a telephone system, flouring mill, a cheese factory and creamery, a bank, four general stores, two harness shops, a lumber yard, two millinery shops, a drug store, two barber shops, two fruit and confectionery stores, a photograph studio, two hardware stores, a meat market, a book and stationary store, a furniture store, three saloons, a hotel, a livery stable, three blacksmith shops, two grain elevators, a doctor, a dentist, a jeweler, a cigar factory, a brickyard, a shoe store, a tailor, a good system of water works, two hose companies, a weekly newspaper, a wagon shop, and one brass band. (Photo courtesy of Julie Schrader.)

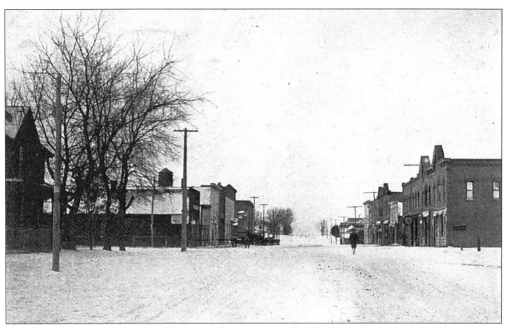

This winter scene is of Good Thunder Main Street in 1908. (Photo courtesy of BECHS.)

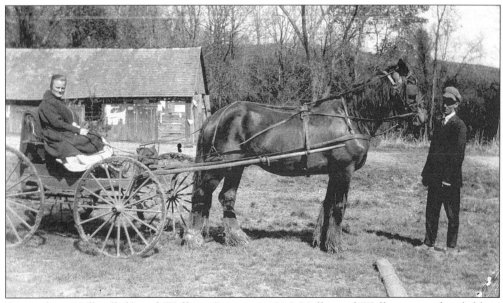

Pictured are Nellie (left) and Wallace Grover, c. 1916. Nellie and Wallace were the children of Scott and Hattie Grover who lived on a farm just north of the Sterling Center Store and the District #31 Sterling School. (Photo courtesy of Wesley and Harriet Bonnett.)

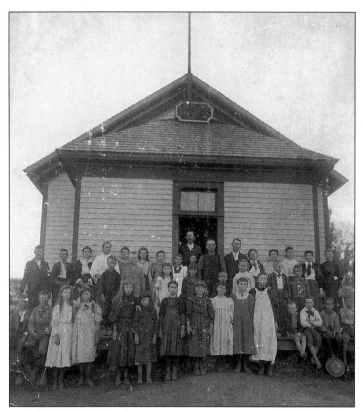

Established in 1858, School District #31 had many children, as shown in this 1880s photo. The teacher, Thomas Benedict, is standing in the doorway on the left. (Photo courtesy of Wesley and Harriet Bonnett.)

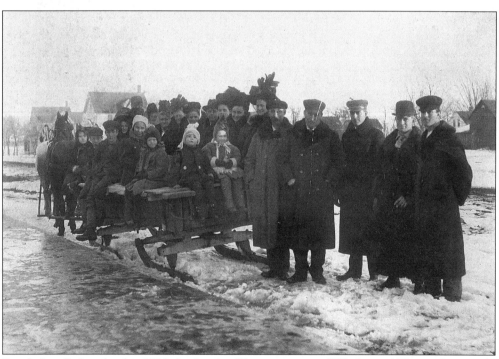

People bundled up for this 1910 sleigh ride. (Photo courtesy of Wesley and Harriet Bonnett.)

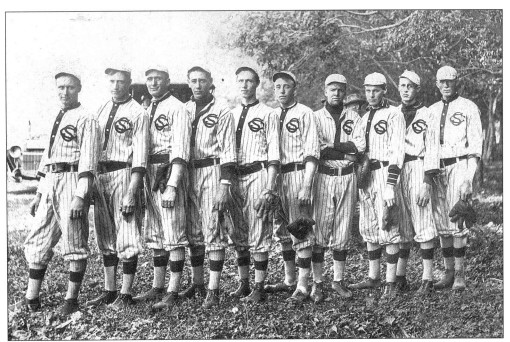

This was the Sterling Baseball Team, c. 1915. Pictured, from left to right, are as follows: Bob Olson, three unidentified, Corliss Grover, Harvey Irvine, Harvey Keith, and three more unidentified. (Photo courtesy of Wesley and Harriet Bonnett.)

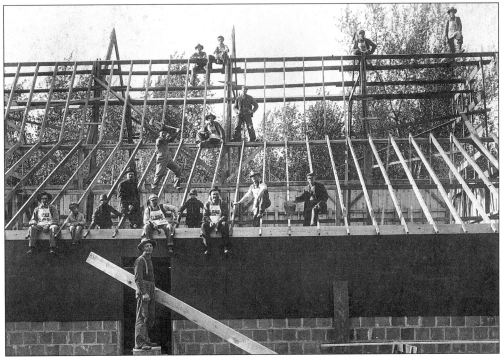

Building a barn on the C.H. Grant Hazel farm in Sterling Township, c. 1897. (Photo courtesy of Wesley and Harriet Bonnett.)

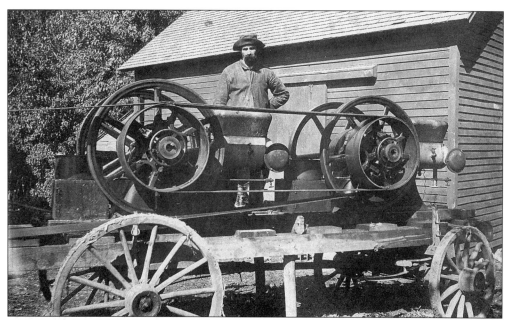

C.H. Grant Hazel filled his silo with the aid of a steam engine, *c.* 1920. He farmed in Section 21 of Sterling Township. Mr. Hazel served as a Blue Earth County representative in the state legislature during the 1925 and 1927 sessions. (Photo courtesy of Wesley and Harriet Bonnett.)

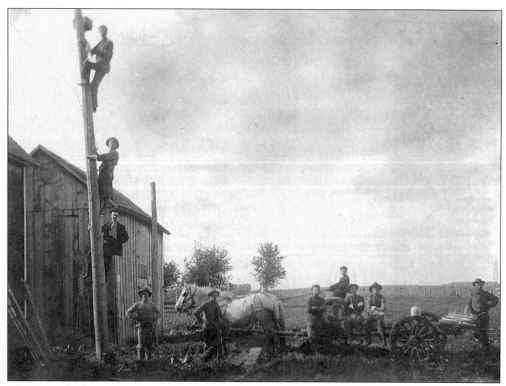

The first telephone line from Good Thunder through Sterling Center to Amboy was strung about 1919–1920. Corliss Grover is on the pole. (Photo courtesy of Wesley & Harriet Bonnett.)

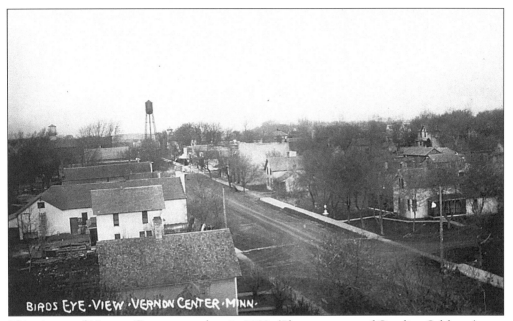
This picture of Vernon Center was taken in 1908. (Photo courtesy of Caroline Salsbery.)

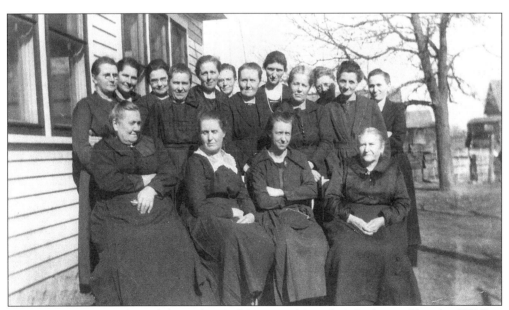
This group of women formed the Ladies Aid Society of St. John's Lutheran Church of Willow Creek, c. 1888. (Photo courtesy of Myrtle Westphal.)

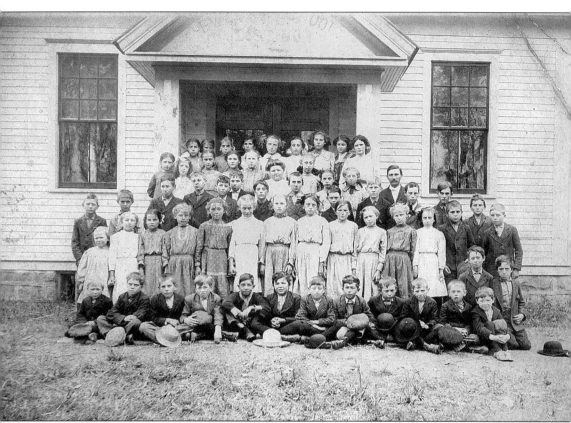

This photo is of the Willow Creek School in 1910. Pictured, from left to right, are as follows: (first row) Reinhold Bode, Arnold Kopischke, Martin Klaus, John Bode, Friebert Tabott, Walter Stolzmann, Edwin Henslin, Rueben Kietzer, Otto Meyer, Gilbert Urban, Anton Kietzer, and Arnold Urban; the two kneeling boys are unidentified; (second row) Frieda Bode, Gertrude Kietzer, Helen Tonn, Ella Mees, Hertha Wollschlager, Ida Mascherski, Martha Urban, Ella Ulrich, Leona Kopischke, Elisabeth Kietzer, Laura Mees, Arthur Urban, Herman Tonn, and Otto Klaus; (third row) Erich Mascherski, David Mees, Ervin Boeck, Martin Herrlich, George Meyer, Ben Boeck, John Kopischke, August Urban, unidentified, Herbert Schwarz, and Erich Seeman; (fourth row) Hulda Urban, Otielia Cloder, Erna Bergeman, Bertha Tonn, Bertha Wojahan, Meta Stolzman, Lillie Paap, Ella Paap, Lena (?), and teacher Henry Bode; (fifth row) Minnie Black, Frieda Glaubitz, Hulda Black, Erna Kopischke, Esther Schwarz, Margaret Marlow, Lydia Wester, Esther Urban, and Erna Luedtke.

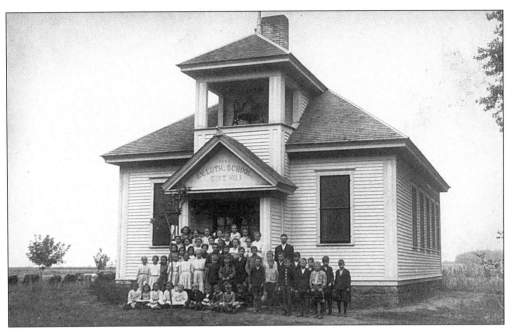

Teacher and pupils assemble in front of the Evangelical Lutheran School, District #1, at Willow Creek, c. 1915. (Photo courtesy of Myrtle Westphal.)

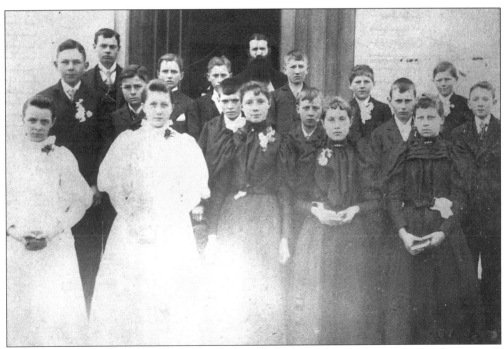

This is the 1896 confirmation class of St. John's Lutheran Church in Willow Creek. Pictured, from left to right, are as follows: (front row) Johanna Trupke, Amanda Urban, Marie Kietzer, Minna Zellmer, and Mathilda Mees; (back row) Wilhelm Hardtke, Wilhelm Wilde, Herman Nibbe, Wilhelm Boelke, Herman Bergemann, Rudolf Bergemann, Ernest Wester, Wilhelm Krause, Theodore Schwarz, Rudolf Schulz, Eduard Suelflow, and Alfred Radtke.

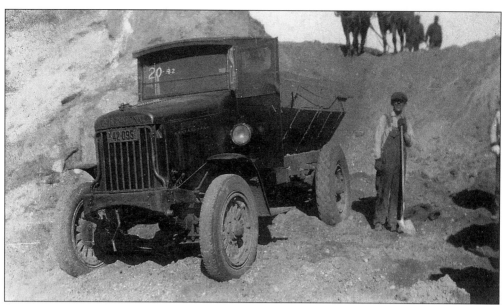

Alvin Krause takes a break and leans on his shovel while working in Emil Luedtke's gravel pit in Pleasant Mound Township, c. 1928. (Photo courtesy of Myrtle Westphal.)

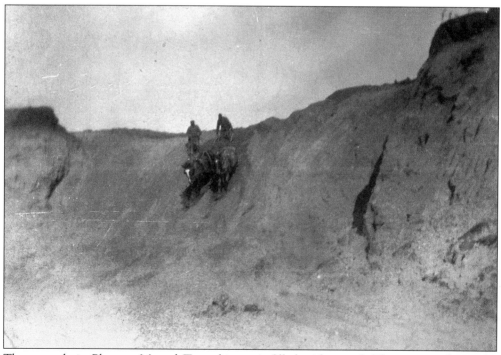

The mounds in Pleasant Mound Township were filled with gravel. This picture shows the beginning of a large gravel pit, which furnished the gravel for many roads in the area. c. 1928. (Photo courtesy of Myrtle Westphal.)

Alvin Krause is pictured here in 1908 (age 1) dressed in his fancy sailor suit. (Photo courtesy of Myrtle Westphal.)

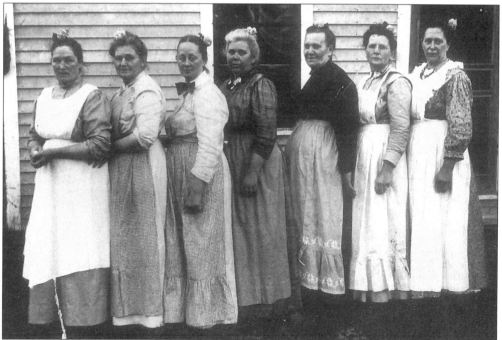

The cooks at the large double wedding of Lydia Urban to Rudoph Malchow and Tina Kietzer to Albert Urban on May 28, 1913, are pictured, from left to right, as follows: Mrs. Emil (Kietzer) Luedtke, Rose (Urban) Schwartz, Ernestina (Klaus) Kietzer, Emilie (Witt) Urban, Johannah (Wilke) Urban, Anna (Bergmann) Urban, and Wilhelmina (Schwarz) Urban. (Photo courtesy of Myrtle Westphal.)

This four-generation photo was taken in 1918. Pictured, from left to right, are as follows: (front row) Hildegard (Reinke) Johnson and Augusta (Wudtke) Schulz; (back row) Hanna (Wilke) Reinke and Augusta (Schulz) Wilke. (Photo courtesy of Myrtle Westphal.)

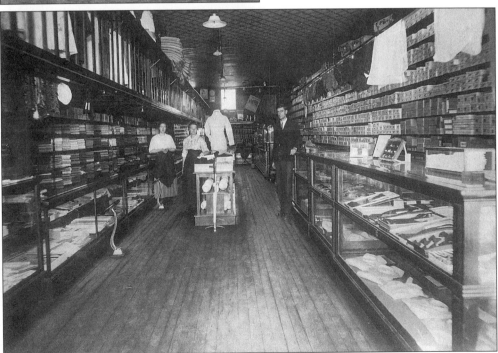

Clara Krause, unidentified, and Herbert Salsbery, in J. Vold's store in Amboy, c. 1908. (Photo courtesy of Tom Salsbery.)

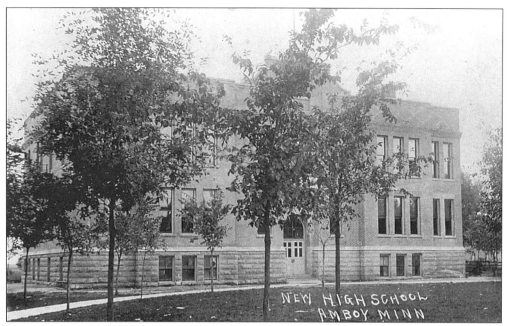

On April 26, 1909, a fire destroyed Amboy's high school. The new high school, which was completed and opened for school the fall of 1909, is pictured here. (Photo courtesy of Caroline Salsbery.)

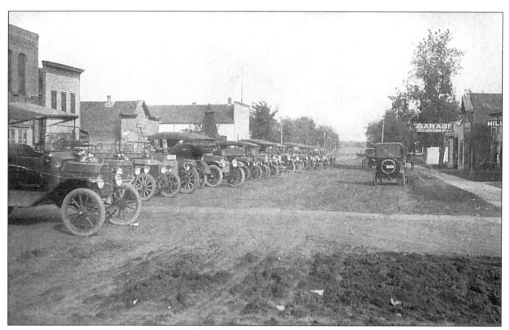

Automobiles are lined up on Amboy's Main Street, c. 1918. (Photo courtesy of Caroline Salsbery.)

The Albert Urban homestead was located in Section 4 of Pleasant Mound Township. This 1893 photo shows, from left to right, as follows: Minnie (Urban) Mees, Amanda (Urban) Vandrey, Frieda Urban, Mrs. Johanna (Wilke) Urban, Hanna (Urban) Weinkauf, Gustav Urban, and George Albert Urban. (Photo courtesy of Myrtle Westphal.)

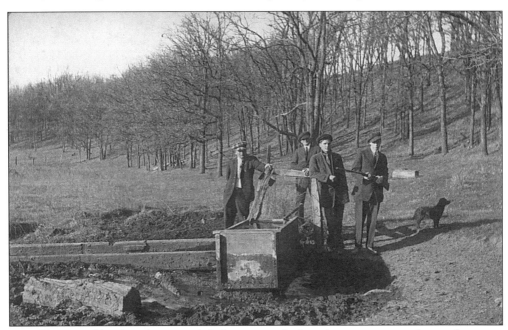

Louis Krause and his friends pause while hunting with their dog at a water tank on a farm near Amboy, c. 1910. (Photo courtesy of Caroline Salsbery.)

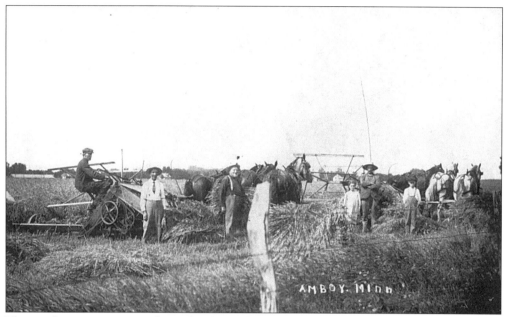
This is a harvesting crew with two binders and teams near Amboy, c. 1913. (Photo courtesy of Caroline Salsbery.)

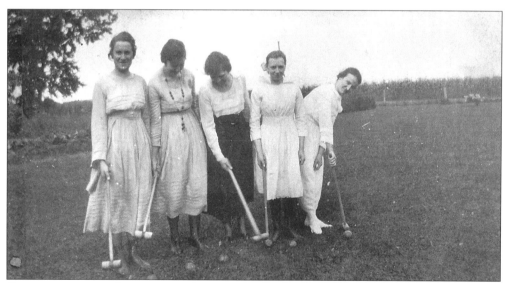
Croquet was a popular sport in 1918. Five women of Ceresco Township enjoy a summer afternoon on the lawn. Pictured, from left to right, are as follows: Martha Urban, Ella Mees, Hertha Ritz, Frieda Bode, and Rose Schwarz. (Photo courtesy of Myrtle Westphal.)

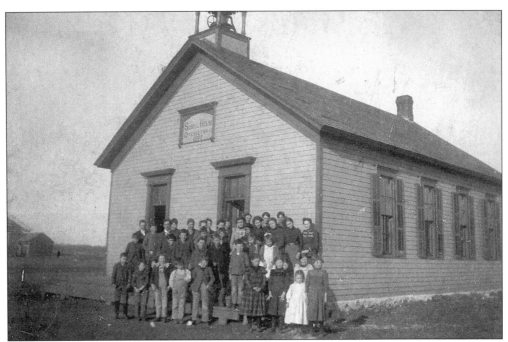
School District #11 was established in 1856 in Cambria Township. It was located near the Horeb Calvinistic Methodist Church and therefore was called the Horeb School, c. 1895. (Photo courtesy of BECHS.)

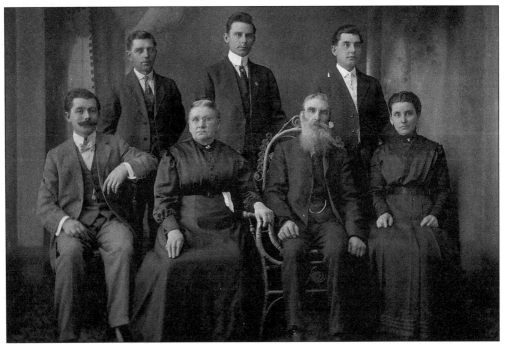
The William Friedrich Vandrey family lived in the Willow Creek area, c. 1920. Pictured, from left to right, are as follows: (seated) Adolph, Rosina, William F., and Minnie; (standing) William E., Herman, and Reinhold. (Photo courtesy of Myrtle Westphal.)

## Four
# THE NORTHWEST

## THE TOWNSHIPS OF BUTTERNUT VALLEY, CAMBRIA, GARDEN CITY, JUDSON, LINCOLN, RAPIDAN, AND SOUTH BEND

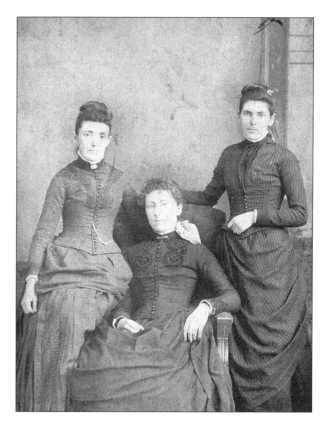

Anne and Margaret Lloyd grew up in Butternut Township. Anne attended the first class at the Mankato Normal School (which later became Mankato Teacher's College) and was a teacher in Blue Earth County Schools for 25 years. Pictured, from left to right, are Anne Lloyd, Margaret Lloyd, and Miss Wilson. (Photo courtesy of BECHS.)

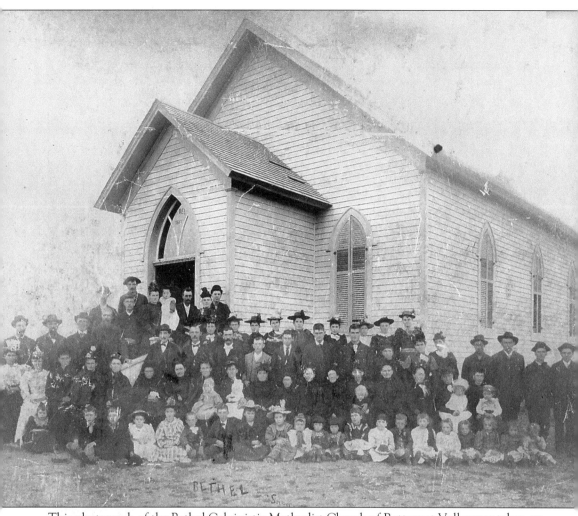

This photograph of the Bethel Calvinistic Methodist Church of Butternut Valley was taken on July 20, 1894. The parishioners are, from left to right, as follows: (first row) Ellen Gwen Evans, Calvin Owens, Tommy Owens, Edna Grace Evans, Lizzie Mary Evans, Moses Morris, Aaron Morris, a visitor from Kansas, Rachel Jones, visitor from Kansas, Jane Hughes, Susie Hughes, Winnie Hughes, Addie Mary Jones, Eben Owens, Maggie Davis, Hattie Davis, Eunice Davis, Hannah Thomas, Esther Thomas, and Jennie Thomas; (second row) Mrs. Edward Roberts, Alice Jones, Mrs. John Evans, Visitor from Kansas, Mrs. John C. Jones, Mrs. Thomas Thomas, Mrs. Wm. Williams, Mrs. Wm. Morris holding Naomi, Mrs. John Pugh holding Jennie, Mrs. John R. Owens, Mrs. Wm. Francis, Mrs. Joseph Williams, Mrs. Robert Thomas, Mrs. Wm. Pritchard holding Willie, Mrs. Robert Hughes, Mrs. Mary Jones, Mrs. John Davis, his daughter Eva, Mrs. Lizzie Walters, and her son Dannie; (third row) Robert I. Jones, John R. Owens, Robert Thomas, Wm. S. Hughes, John Evans, Richard J. Williams, Owen Williams, Owen Owens, John L. Jones, Robert Hughes, Everett Thomas, Will S. Hughes, Mary Thomas, Katie Hughes, John T. Davis, John Pugh, Tommy C. Jones, and Eddie Owens; (fourth row) Dr. Ed Roberts, Wm. Pritchard, Tom Williams, Mrs. Robert I. Jones and son Gwesyn, John E. Owens, Lizzie Williams, Will E. Thomas, Lizzie Ann Owens, Dora Owens, Katie Hughes, Lizzie Jones, Maggie Hughes, Mary Ann Jones, Hannah Jones, Miriam Morris and Miriam Thomas. (Photo courtesy of BECHS.)

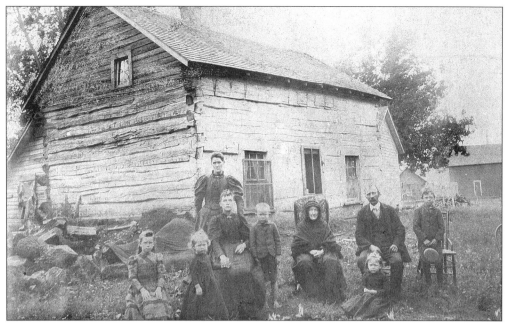

Here is the residence of William and Sarah Harris in Cambria Township. Pictured, from left to right, are as follows: (seated) Mrs. Evan Harris, Mrs. William (Sarah) Harris (age 89), and Evan Harris (the names of the children of Mr. and Mrs. Evan Harris are unknown); (standing) Miss Catherine Hughes. Mr. William Harris was deceased when this picture was taken. During the mid-1860s the Salem Congregational Church held services at the home of William Harris. (Photo courtesy of BECHS.)

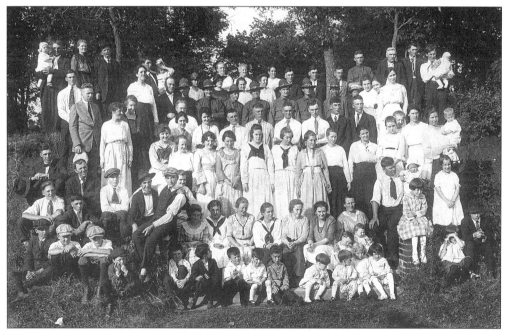

This 4th of July celebration was held in Cambria at Wagner's Grove, c. 1919. Note the row of men dressed in World War I uniforms. (Photo courtesy of LaVola Lewis.)

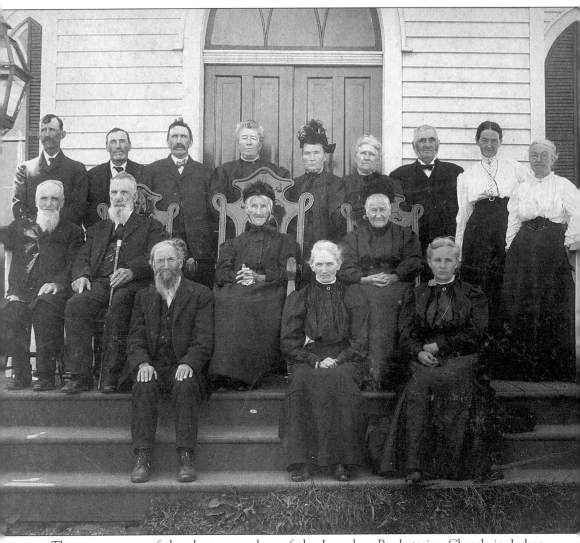

These were some of the charter members of the Jerusalem Presbyterian Church in Judson Township. This photo was taken at the 50th anniversary of the church on July 11, 1908. Pictured, from left to right, are as follows: (seated) Rev. Wm. Machno Jones (first pastor of the church), Wm. R. Jones, David Dackens, Mrs. Wm. Bowen, Mrs. Hugh A. Jones, Mrs. D.D. Evans, and Mrs. Wm. W. Evans; (standing) Carodog Jones (the first baby baptized at the church), Humphrey Roberts, Henry R. Roberts, Mrs. Owen Roberts, Mrs. Robert Thomas, Mrs. Albert Jones, Rev. John W. Roberts, Mrs. John W. Roberts, and Mrs. Wm. Machno Jones. (Photo courtesy of BECHS.)

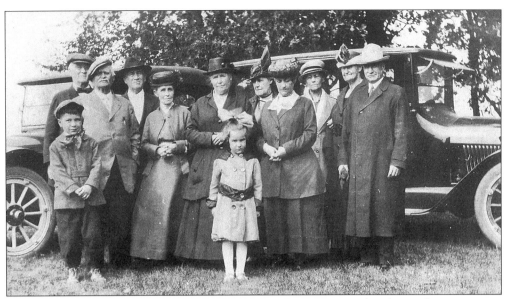

Malachi Gainor was a county commissioner representing Lyra Township during the controversy in the mid-1880s over a new county courthouse building in Mankato. Many voters outside of Mankato were against building the new courthouse in Mankato rather than Garden City. After bitter opposition, the issue was finally resolved: the courthouse, in Mankato, was completed October 1, 1889. This is a picture of Malachi Gainer's family, c. 1920. (Photo courtesy of Wesley and Harriet Bonnet.)

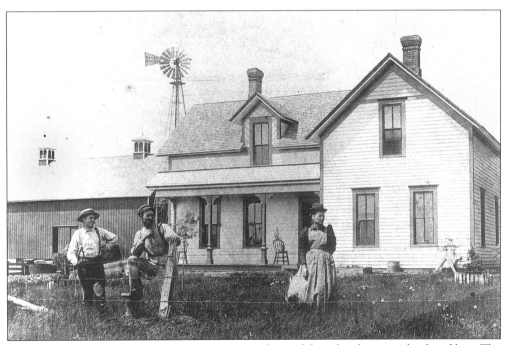

William and Jane Wigley stood for this picture in front of their farmhouse with a hired boy. The house was built in 1886, the same year William and Jane were married. (Photo courtesy of BECHS.)

Sophia Beckman, born in 1868, was the daughter of Swedish immigrants John and Mary Beckman. The Beckman family homesteaded land in Judson Township. Sophia Beckman married Alfred Anderson. Andersons still live on the Blue Earth County century farm, known as the Anderson Farm. (Photo courtesy of Mildred M. Monsen.)

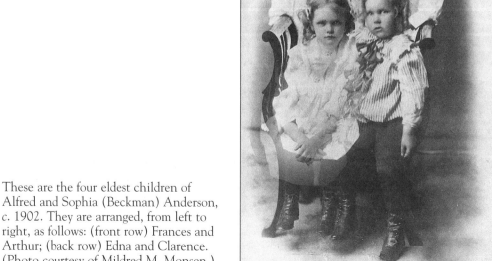

These are the four eldest children of Alfred and Sophia (Beckman) Anderson, c. 1902. They are arranged, from left to right, as follows: (front row) Frances and Arthur; (back row) Edna and Clarence. (Photo courtesy of Mildred M. Monsen.)

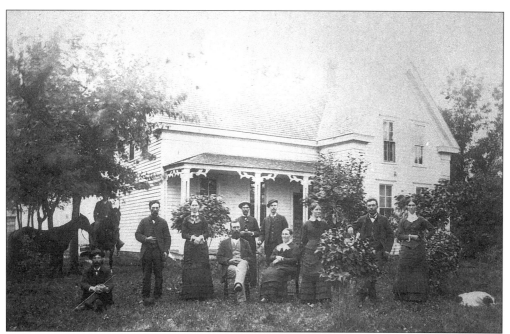

This was the home of Thomas Williams in rural Lake Crystal, c. 1885. Seated, from left to right, are as follows: Thomas D. Williams and his wife Sarah, William R. Thomas, Ed Jones, Margaret Jane (Williams) Davis, Mary Ann (Thomas) Jones, John Thomas, Rose Thomas, and David Thomas; two people standing in back are identified as Alice Williams and David Thomas. Thomas Williams and 18 of his neighbors went to the defense of New Ulm during the Dakota Conflict of 1862. (Photo courtesy of BECHS.)

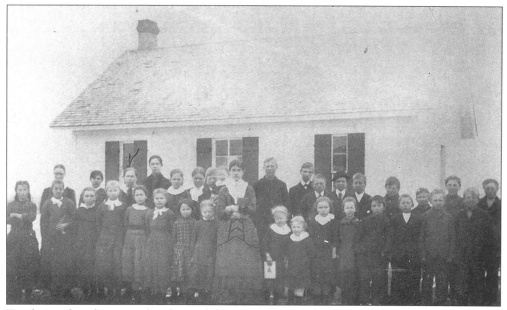

Teacher and students stand in front of the Judson schoolhouse in this early-1880s photograph. The "V" marks Sophia Beckman. (Photo courtesy of Mildred M. Monsen.)

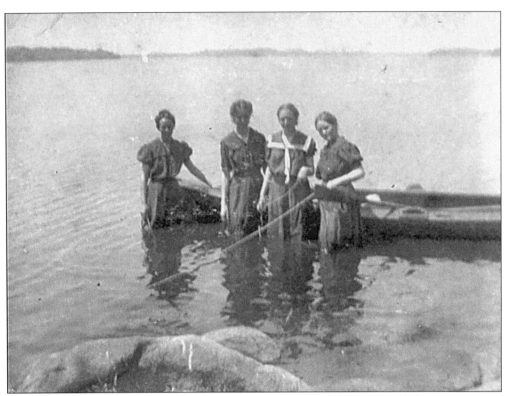
Four women spend the day at Lake Crystal near the turn of the century. (Photo courtesy of BECHS.)

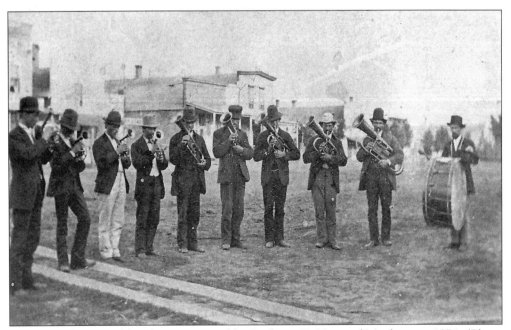
The first Lake Crystal band was organized by Professor E. Howe of Mankato, c. 1874. (Photo courtesy of Tom Owens.)

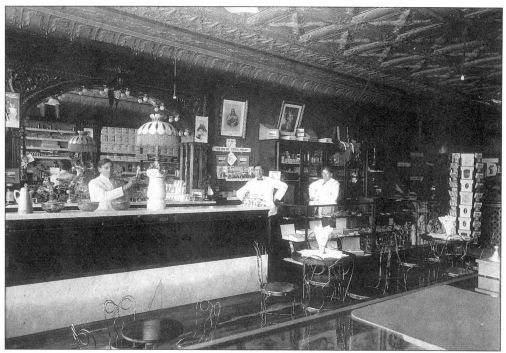

In 1914, the place to stop for refreshments in Lake Crystal was Dick Espenson's Restaurant at 101 West Main Street. Pictured, from left to right, are as follows: Richard Espenson, George Espenson, and Tom Owens. (Photo courtesy of Mrs. Tom Owens.)

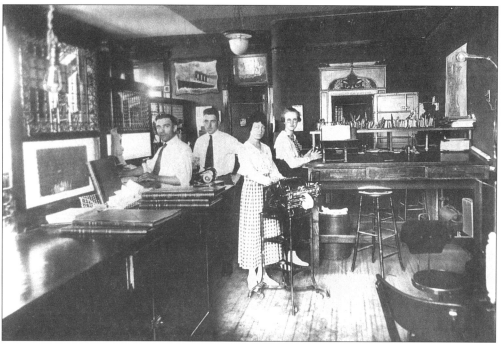

This was the interior of the First National Bank of Lake Crystal, c. 1918. (Photo courtesy of BECHS.)

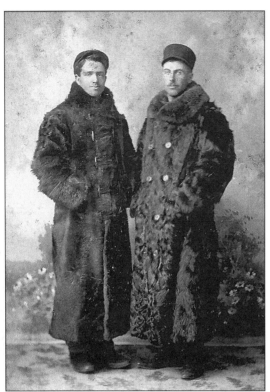

Keeping warm during the cold, harsh Minnesota winters was difficult. This picture, taken in the late 1800s, shows the men's fur coats. Pictured with his friend is Ed "D.J." Davis (left) who farmed on Lily Lake near Lake Crystal. (Photo courtesy of Jo Schultz.)

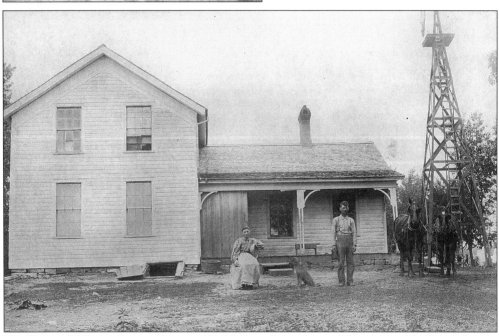

The Robert Williams farm in Section 13 of Judson Township was later owned by Ben Edwards. Robert and Elizabeth Williams had three daughters: Mabel, Margaret, and Mary. Mary died at age 18 of appendicitis. Mabel married Elmer Johnson and lived to the age of 100. Margaret married Ed "D.J." Davis and they farmed near Lily Lake. (Photo courtesy of Jo Schultz.)

Kenneth and Clifford Adams at play on their farm home near Garden City in this c. 1901 image. (Photo courtesy of BECHS.)

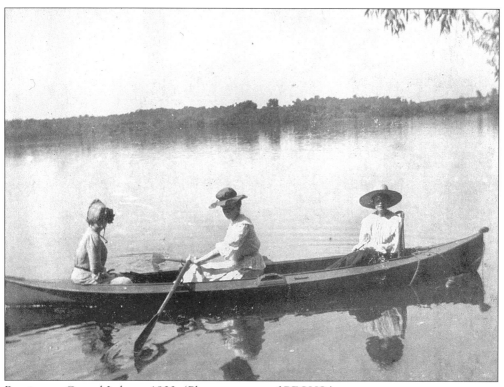

Boating on Crystal Lake, c. 1900. (Photo courtesy of BECHS.)

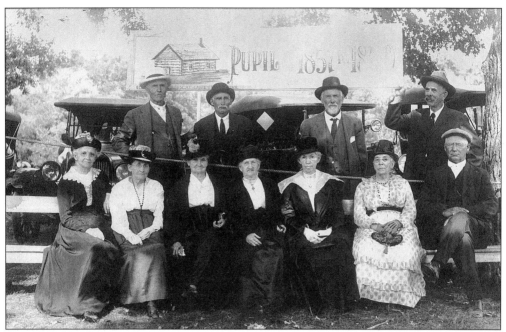

The Classes of 1857–1860 of the Old Log School House in Garden City, reunite in this image. This photograph was taken at the Blue Earth County Fair, c. 1912. Pictured, from left to right, are as follows: (seated) Julia Marvin Thurston, Angie Gerry Pepper, Henrietta Skinner Rue, unidentified, Mrs. H.O. Thompson, Fanny Howard Capen-Robinson, and unidentified; (standing) Ezra Gates, Gene T. Thompson, H.O. Thompson, and Frank Thurston. (Photo courtesy of BECHS.)

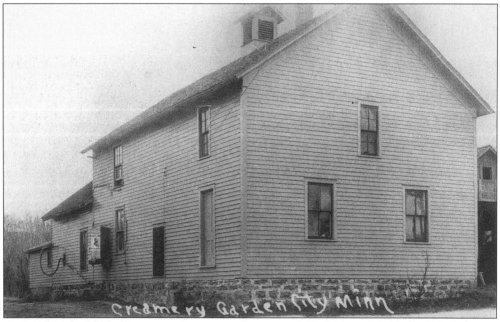

The Garden City Creamery began operation in April 1895, and soon after added a cheese factory. Much of the cheese and butter was shipped out of the village. The cheese factory closed before 1910, but the creamery stayed in business until the middle 1950s. (Photo courtesy of BECHS.)

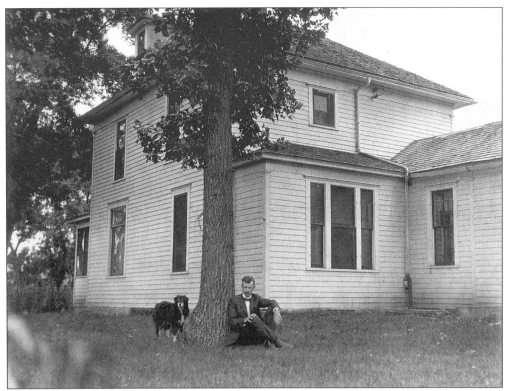
This photograph shows the Ed J. Naylor family home in Garden City. (Photo courtesy of BECHS.)

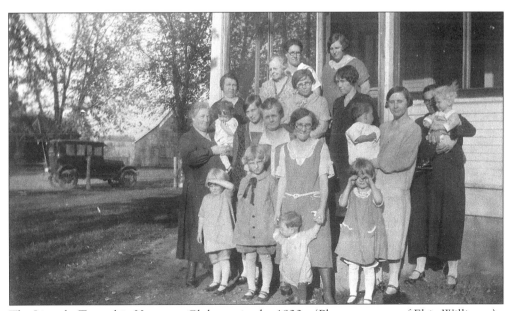
The Lincoln Township Harmony Club met in the 1920s. (Photo courtesy of Elsie Williams.)

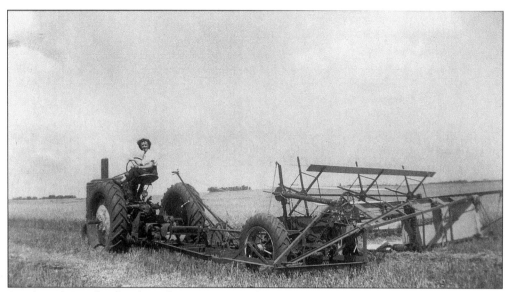
Swathing grain for threshing became easier when rubber tires came into widespread use as shown on this Lincoln Township farm. (Photo courtesy of Elsie Williams.)

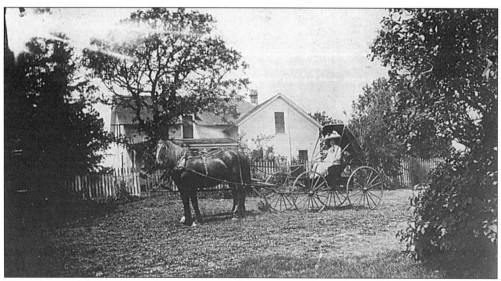
Wearing an elaborate hat, this woman in the horse and buggy calls on friends at the F.A. Fredericksen farm in Lincoln Township, c. 1900. (Photo courtesy of Elsie Williams.)

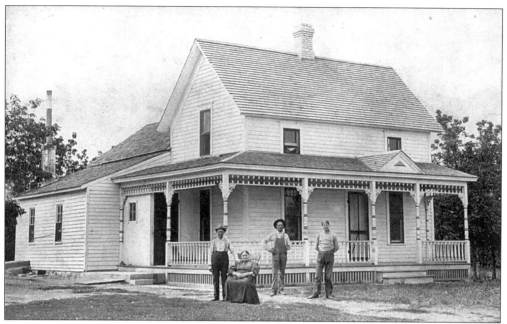

Above is a 1908 picture of F.A. Fredericksen (left) with his parents Johanna and John Fredericksen and friend Alfred Hansen. The Fredericksen farm was located in Lincoln Township. (Photo courtesy of Elsie Williams.)

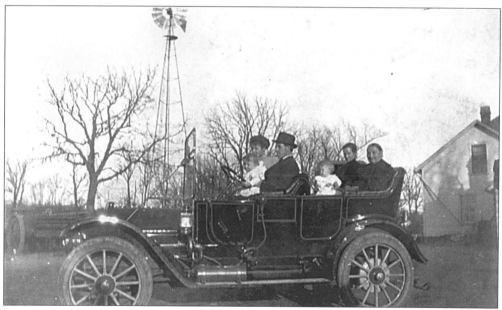

Marius Fredericksen drives his 1915 Reo in the above image. In front with him are Tina and Milton Fredericksen. In the back seat are Mary Peterson and Johanna Fredericksen. The Presto lights on the car were lit with a match. Note the tank of gasoline on the running board of the car. (Photo courtesy of Elsie Williams.)

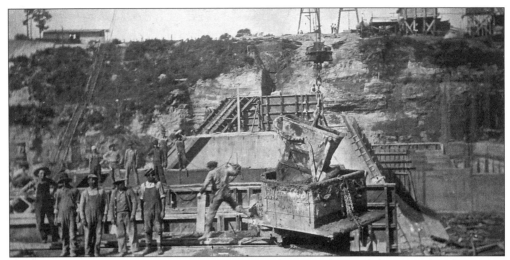

Laborers work on the Rapidan Dam, receiving $1.75 a day and $1.00 a day for teams. Approximately 200 people worked on the dam—local people and also Bohemian and Italian laborers from Chicago. Crews worked seven days a week, day and night. The Rodgers flour mill at Rapidan Mills was remodeled into a boarding house and sleeping quarters for the laborers. (Photo courtesy of Steve and Beverly Annis.)

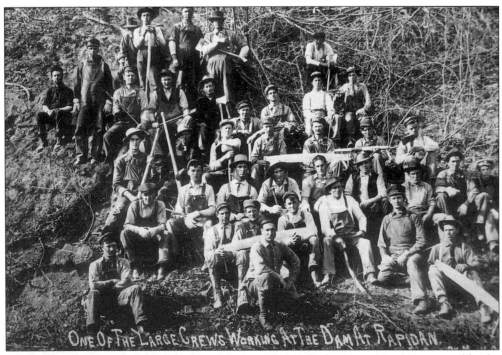

Steel towers were erected on each side of the river from which were strung immense cables for carrying of large concrete buckets. The dam contains over 20,000 cubic yards of reinforced concrete. The hydroelectric hydro-gravity dam, built by the Ambursen Hydraulic Construction Co. of Boston in 1910, was a hollow concrete structure founded in sandstone bedrock. The structure's overall length was 414 feet and the height was 83 feet. (Photo courtesy of Steve and Beverly Annis.)

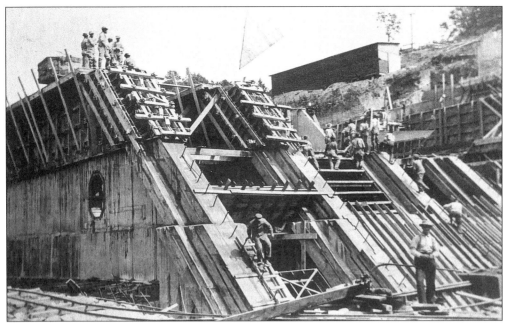

Laborers work on the east buttress of Rapidan Dam. The Rapidan Dam was built at Rapidan Mills on the Blue Earth River in 1910. The first electricity from the Rapidan hydroplant's two 750-kilowatt General Electric flowed into Mankato on March 11, 1911. Rapidan Dam is still producing electricity today. Triangular buttresses extending the whole depth of the dam are evenly spaced from one end to another and are covered with the angled upstream apron and downstream rollway. (Photo courtesy of Steve and Beverly Annis.)

Pictured is a group of neighbors from Rapidan Township who got together each year to thresh grain, c. 1912. From left to right, they are as follows: (front row) Al Nichols, Herman Tischer, and Charlie Possin; (back row) Carl Pasbrig, Albert Possin, Stanley Hawes, (?) Stratton, and Bill Possin. (Photo courtesy of Julie Schrader.)

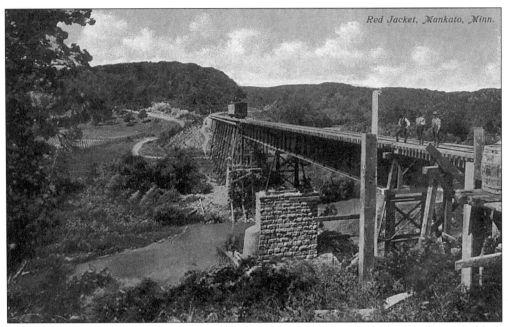

The Red Jacket trestle was built in September 1874. An engineering feat, it was the crucial link in opening southern Minnesota grain fields to the mills in Mankato and vicinity. (Photo courtesy of Agnes Sellers.)

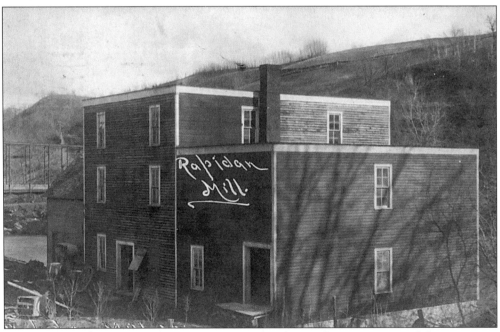

The Rapidan Mill was located near Rapidan on the Blue Earth River, c. 1900. (Photo courtesy of Edith Herzberg.)

This is the Ernest and Anna (Nitschke) Tischer farmstead, c. 1913. Ernest and Anna Tischer immigrated from Germany in 1884 with their three children, Ernest William, Dorothea, and Elizabeth. They came directly to Rapidan Township and lived in a granary on the farm of Carl Matzke Sr. until they were able to find a place of their own. In April 1889, they purchased 40 acres of land in Rapidan Township. Here, they raised their family which included two more children—Emma and Herman. Pictured, from left to right, are as follows: Ernest and Anna Tischer, Hattie (Behnke) Tischer holding daughter Rena, and Herman Tischer. (Photo courtesy of Julie Schrader.)

The only identified persons in this photo of the Indian Lake Sunshine Club in the front row are Ruth Kidder and Lillian Duffey, second from the left. The woman sitting behind the child on the sled is Mrs. Kern. Second row, fourth from the left in white blouse is Anna Garberg. Back row on the left is Mrs. Kidder and the fourth woman holding the baby is Mrs. Duffy. (Photo courtesy of BECHS.)

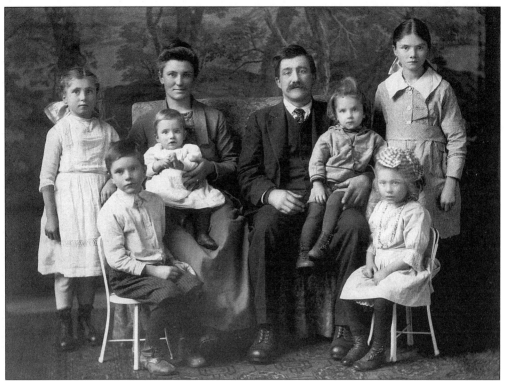

The Charles Griffith family is shown, left to right, as follows: Mildred, Les, Jesse holding Clayton, Charlie holding Jay, Ethel (standing), and Beatrice. (Photo courtesy of Helen Griffith.)

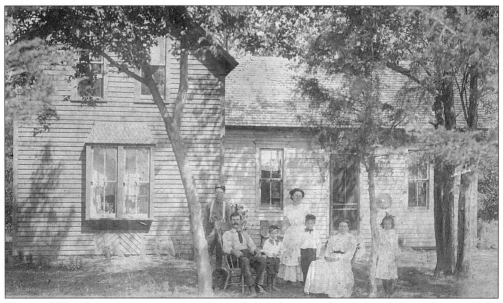

The Fred Hanel family is pictured in front of their home in South Bend Township, c. 1895. They are, from left to right, as follows: Carl, Fred, Herman, Lena, Fred Jr., Dorothy, and Anna. (Photo courtesy of Helen Griffith.)

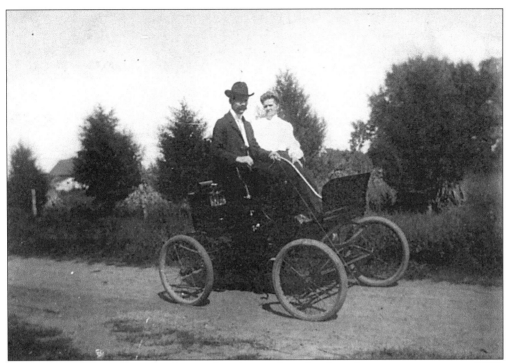

Alvin Laird of LeHillier takes his mother for a ride in his horseless steam carriage in 1897. (Photo courtesy of BECHS.)

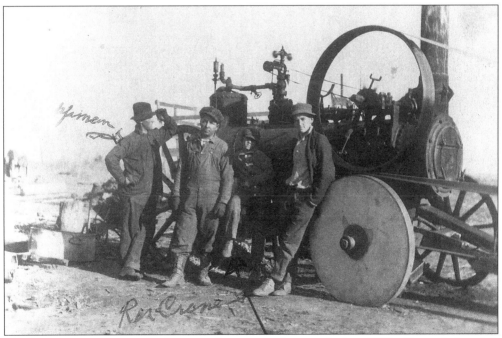

The first steam tractor on the Seppman farm is seen here in the late 1800s. Pictured, from left to right, are as follows: William Seppman, unidentified, Ron Crane, and Walter Seppman. The Seppman farm was located in South Bend Township. (Photo courtesy of Darlene Matteson.)

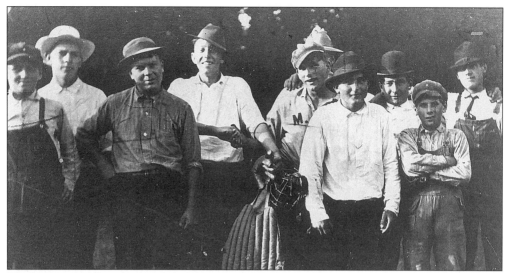

This 1919 softball team played their games at Minneopa Park. On the far right in the front row is Willie Seppman. (Photo courtesy of Darlene Matteson.)

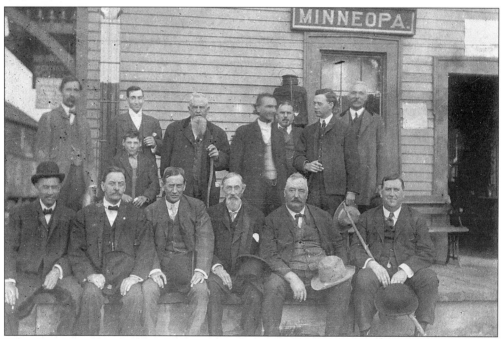

This photo was taken on the platform of the Minneopa Depot at the negotiation meeting for the purchase of Minneopa State Park on October 13, 1905. Pictured, from left to right, are as follows: (seated) E.T. Young, state attorney general; Samuel Iverson, state auditor; John A. Johnson, governor; General James H. Baker; Orange Little; and John C. Wise of the Mankato *Review*; (standing) Thomas Hughes, a local committeeman; F.G. Cuttle, of Railway Construction; Robert L. Williams (in front of Mr. Cuttle); William W. Paddock, chairman of County Commissioners; Dr. J.W. Andrews, a local committeeman; Joseph R. Reynolds, of the Mankato *Free Press*; William L. Johnson, Superintendent of Railway Construction; and Chas. N. Andrews, a local committeeman. (Photo courtesy of BECHS.)

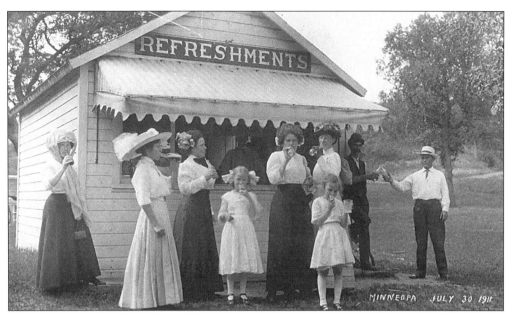

Minnie Hanson Sherer, second from the left, shared a refreshment with her friends at Minneopa State Park. This photo was taken on July 30, 1911. (Photo courtesy of Agnes Sellers.)

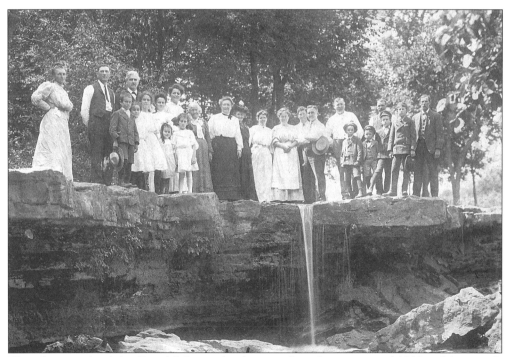

This photograph of the David J. Lewis family was taken the summer of 1910 at Minneopa's upper falls. It shows only a trickle of water in Minneopa Creek. (Photo courtesy of BECHS.)

Charles Chapman, an early surveyor, built this limestone one and a half-story house in LeHillier about 1858. The house had a central hallway and walnut woodwork. The stone came from the George Maxfield quarry on Mankato's north side. (Photo courtesy of BECHS.)

The first settlement of white men in Blue Earth County occurred when a Frenchman, Pierre Charles LeSueur, and his band of 27 men erected a wooden fort in April 1700. This fort was built at the junction of the Blue Earth and LeSueur Rivers south of Mankato. They mined the blue clay in the area and thought they had found copper. In 1926, the DAR, Anthony Wayne Chapter, erected this monument marking the site of the fort. (Photo courtesy of BECHS.)

# Five
# MANKATO AND NORTH MANKATO

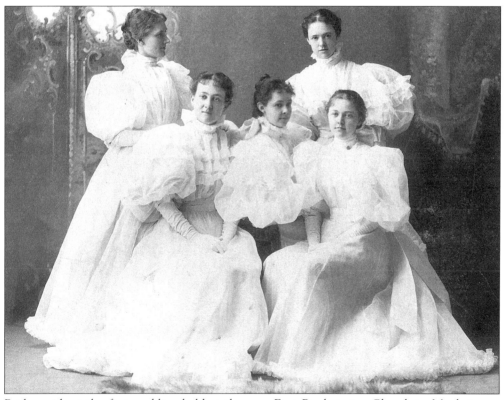

Bridesmaids at the first wedding held at the new First Presbyterian Church in Mankato are pictured above. The wedding of Margaret Reid and Charles Michener was June 30, 1896. The bridesmaids, from left to right, are: (seated) Carrie Robbins, Alice Farr, and Grace Clark; (standing) Isabel Beatty and Cora Carney. (Photo courtesy of BECHS.)

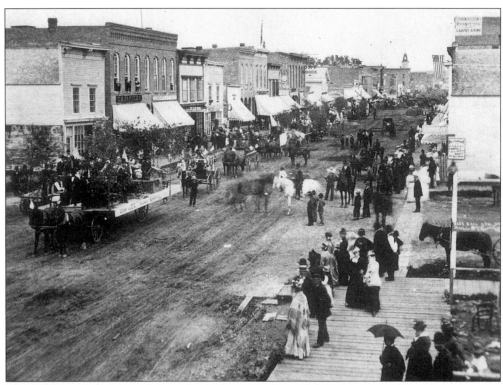
The 1888 parade celebrated the 4th of July in Mankato. (Photo courtesy of Kathleen Cain.)

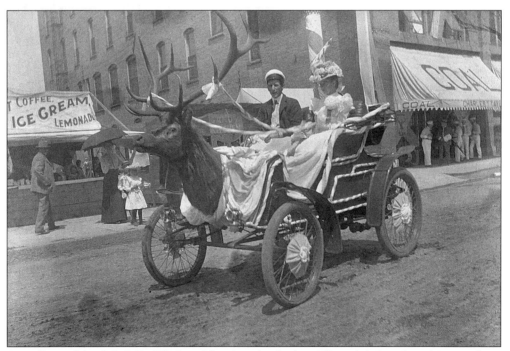
An officer of the B.P.O.E. (Elks) and his friend ride the "Elk-mobile" in the 1901 parade in Mankato. (Photo courtesy of BECHS.)

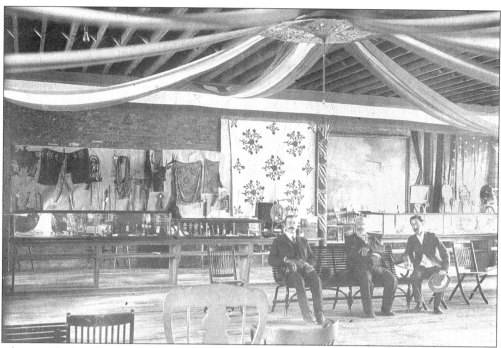

Above is the Mankato museum at the semi-centennial celebration in 1902. This museum was located in the Pay building, 310 South Second Street. Pictured, from left to right, are as follows: H.D. Diamond, John Diamond, and Thomas Hughes. (Photo courtesy of BECHS.)

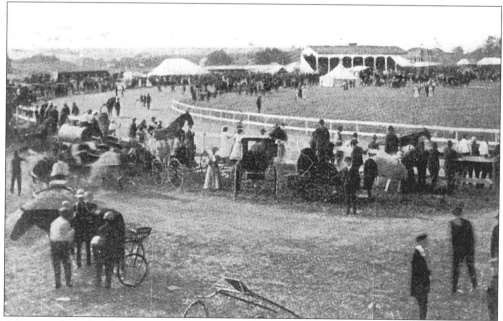

After two short-lived attempts to establish an annual Mankato Fair, a third more successful was begun in 1905 by the Mankato Fair and Blue Earth County Agricultural Association. The fair, held in the area of First Avenue and Chestnut Streets, prospered until the 1930s when financial difficulties caused it to close down. (Photo courtesy of BECHS.)

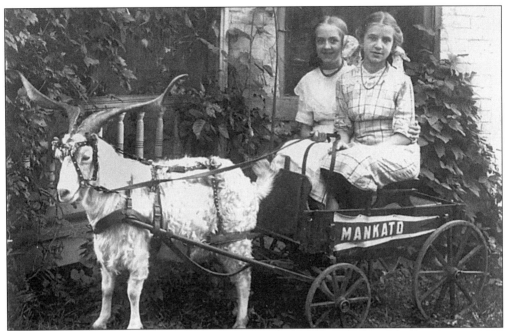

Sisters Ruth and Dorothy Hoxie find a friendly welcome to Mankato in this August 1915 image. Ruth, age 13, and Dorothy, age 11, had recently moved to Mankato from New York City. (Photo courtesy of Shirley Grundmeier.)

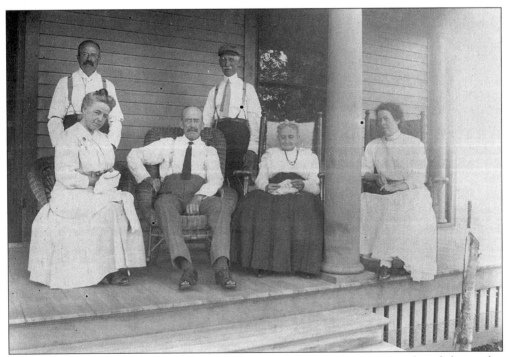

Gathered on the porch of the William Strader home, August 10, 1910, are, from left to right, as follows: Mr. and Mrs. William Strader, D.G. Willard, Charles Alexander, Miss Gould, and Miss Mary Willard. (Photo courtesy of Nadine Sugden.)

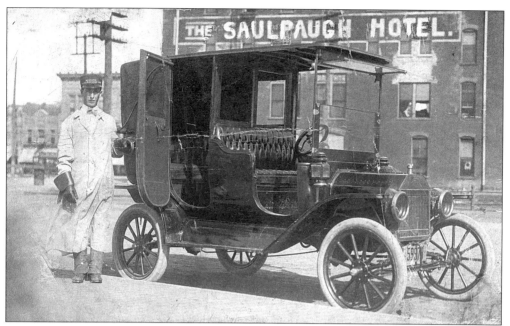

The Coy Taxi Service taxi with chauffeur clad driver pauses in front of the Saulpaugh Hotel awaiting passengers in 1914. (Photo courtesy of BECHS.)

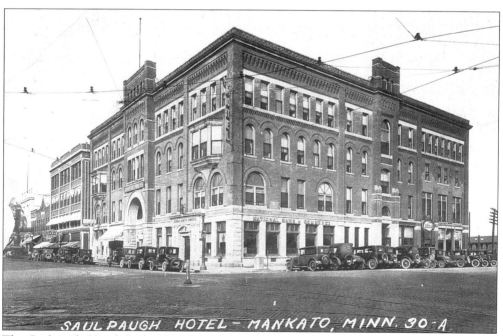

The Saulpaugh Hotel, built 1886–1887, was a busy place around 1920. The hotel was torn down in 1974 during Mankato's urban renewal. The founder and builder, Thomas Saulpaugh, was a stonecutter by trade. Built on swampy land near the Minnesota River, a thousand piles were driven to support the building. (Photo courtesy of BECHS.)

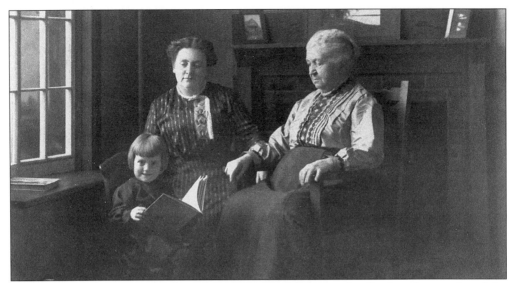

In this *c.* 1913 picture, Phyllis Enfield (Mrs. Fred George) reads a book to her mother, Julia Enfield, and grandmother, Theresa Eich. The three generations all lived in the Enfield Store at 629 North Front Street, Mankato. Phyllis grew up to be an accomplished pianist, teaching and entertaining at many of Mankato's gatherings. She faithfully played for the Kiwanis Club for over 30 years. (Photo courtesy of Jo Schultz.)

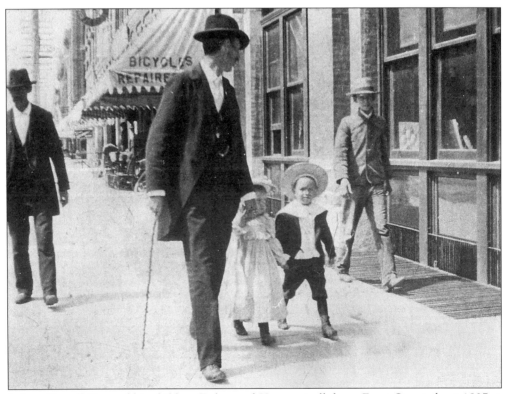

Judson Newell Day and his children Esther and Homer stroll down Front Street about 1897 at the site of the future Grand Theater. (Photo courtesy of BECHS.)

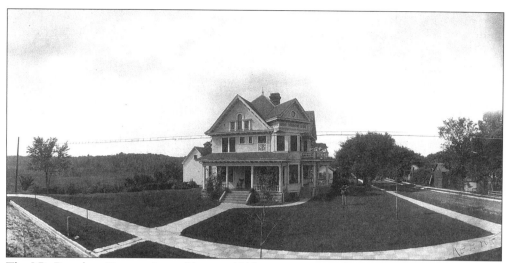

The J.R. Brandrup House, pictured here c. 1910, was constructed at the end of Byron Street in 1904 for J.R. Brandrup. The two and one-half story house is outstanding in the Lincoln Park neighborhood for its prominent setting and elaborate Classical Revival detailing. This home is listed on the National Register of Historic Places. J.R. Brandrup, a German immigrant, received his business training in Minneapolis, MN. He moved to Mankato in 1892 to assume a teaching position with the newly established Northwestern College of Commerce. Soon after, he had acquired one-half interest in the institution and later full ownership. The school later became known as the Mankato Commercial College and remained in operation until its closing in 1982. (Photo courtesy of BECHS.)

Located at 520 South Second Street in Mankato, this home was built by T.O. Jones and his wife Mary. Also pictured are Mrs. W.F. Jones and her daughter, Katie May. The house was later occupied by Dr. and Mrs. H.J. Lloyd and at present is being used as an office building. (Photo courtesy of BECHS.)

This delightful scene was taken about 1888 at the residence of J.H. Long at 228 South Broad Street in Mankato (presently the site of the First Presbyterian Church). Pictured, from left to right, are as follows: Laura Beatty, Mrs. Long, Charlie Long, Mrs. Beatty, Mrs. McCluand, Mrs. Sparrow, Emma Beatty, Marion McCluand, Kate Sparrow, and Belle Beatty. (Photo courtesy of BECHS.)

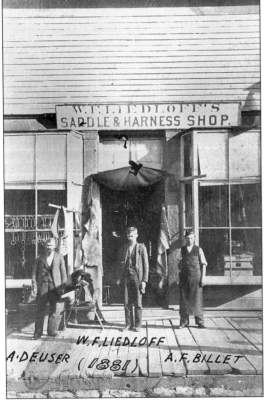

This picture shows W.F. Liedloff Saddle and Harness Shop on Front Street next to the First National Bank building. Pictured, from left to right, are as follows: Anton Deuser, W.F. Liedloff, and A.F. Billet. The crepe was draped over the door in respect for President Garfield, who had been assassinated on September 2, 1881. (Photo courtesy of BECHS.)

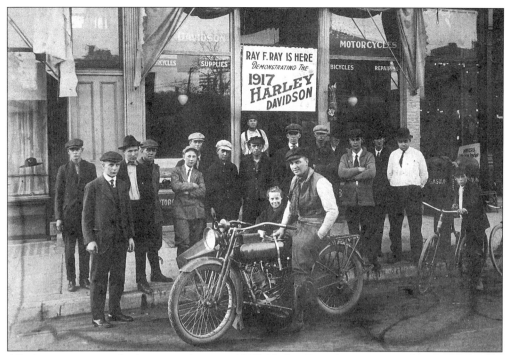

All the young men flock to see the new 1917 Harley Davidson motorcycle at Mahowald's Hardware Store. In 1911, Frank Mahowald started his hardware business with the Mankato Cycle Company. By 1917, he had extended his stock to include a complete line of sporting goods. (Photo courtesy of BECHS.)

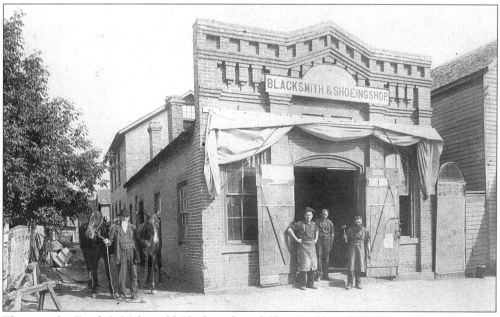

This was the Frank J. Mahowald Blacksmith and Shoeing Shop (628 North Front Street), c. 1910. For many years the Mahowald family operated a hardware and sporting goods store at this location. (Photo courtesy of BECHS.)

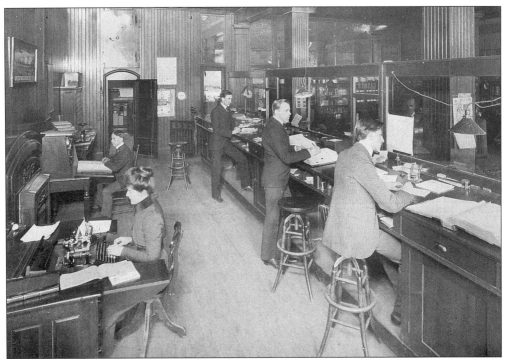

A busy day at the Patterson Mercantile Company is shown about 1900. J.A. Berguist stands at the middle cashier's window. Lester Patterson came to Mankato in 1883 and soon after, he built a four-story business block to house his wholesale grocery company. It became one of the largest wholesale enterprises in the state. (Photo courtesy of BECHS.)

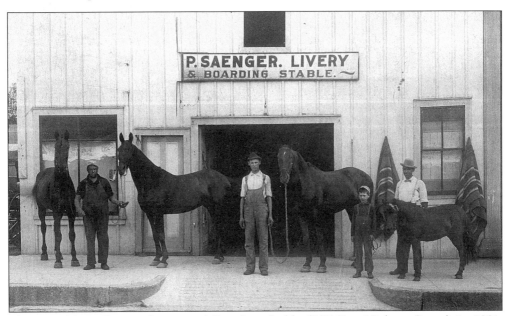

This was the P. Saenger Livery and Boarding Stable (207 East Hickory Street) in 1901. Pictured, from left to right, are as follows: George Peter Saenger, Bill Willmers, Peter, and Robert Saenger. (Photo courtesy of BECHS.)

In the late 1800s, George E. Brett operated the Empire Store at 401 South Front Street in Mankato. The store sold fabrics, notions, buttons, and thread. The Empire Store marked the beginning of over a century of Brett's dry goods merchandising. The owner and employees are gathered in the doorway. (Photo courtesy of BECHS.)

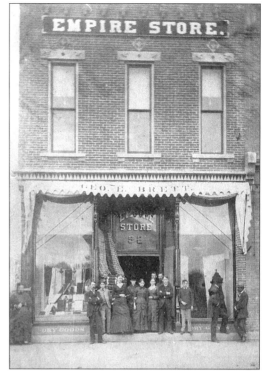

John C. Hagen's Mint Saloon, (225 South Front Street) had a black walnut Victorian bar and a line of waiting customers, c. 1912. From the age of 14, John C. Hagen tended bar in several Mankato saloons before he eventually bought the Mint. (Photo courtesy of Tom Hagen.)

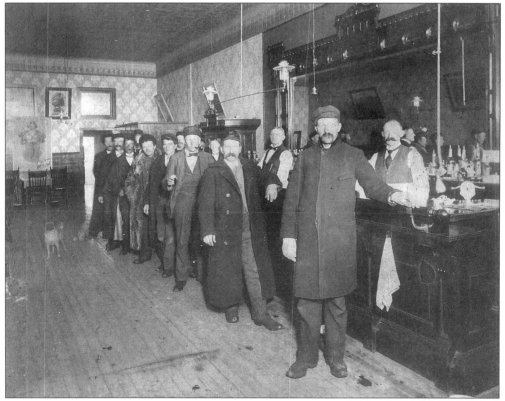

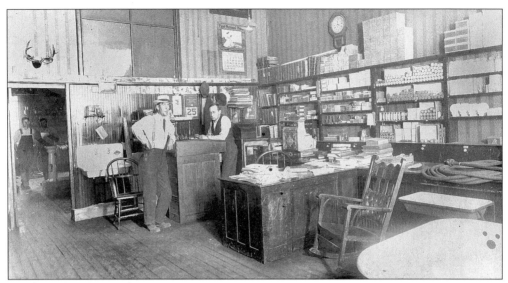

McLaurin and Northrup Plumbers (519 South Front Street) were one of the earliest plumbing businesses in Mankato. In the 1930s, Northrup gave instant approval to the new flat bathtub that replaced the old claw foot tub pictured here because it was easier and safer to use. This photo was taken c. 1912. (Photo courtesy of BECHS.)

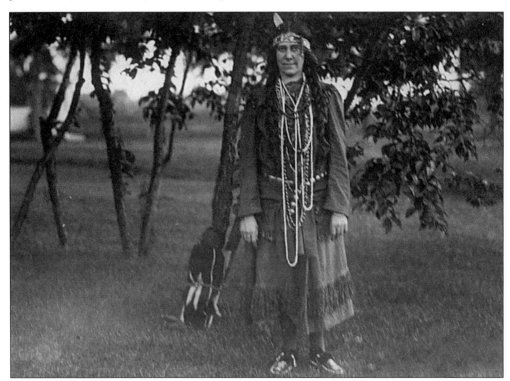

Miss Jessie Irving poses in a Native-American costume at the Mankato 4th of July pageant in 1916. Miss Irving taught for many years at Roosevelt Elementary School. She lived in the restored French-Second-Empire-style house (now Lime Valley Advertising) at 1620 S. Riverfront. (Photo courtesy of BECHS.)

Lafayette G.M. Fletcher (1830–1910) came to Mankato with government surveyors, and in 1854, assisted in surveying Blue Earth County. He later engaged in farming, real estate, banking, and building. He is perhaps best remembered for his interest in education. He helped to build the first school house in Mankato in 1855 and taught the first winter, 1855–56. In 1860 he became a member of the school board and served for many years. (Photo courtesy of Susan Duane.)

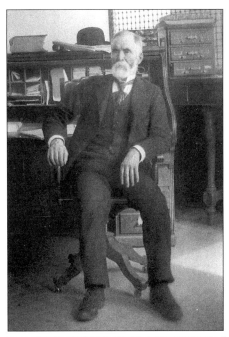

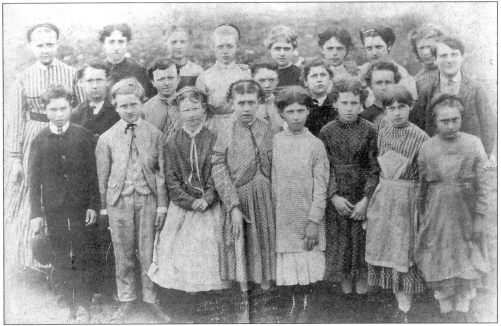

The first school in Mankato (the old log school building) was built on the site of the Union School (presently the Union Square building). This photograph, taken in 1869, was the first class to enter high school. The teacher was Nellie Davis. Pictured, from left to right, are as follows: (front row) Will Spencer, Geo Fletcher, Helen Sterling, Ella Milnor, Lulu McNaury, E. Paddock, Elta Wolobeu, and Lilla Roberts; (middle row) Ed Higgins, Luther McMahill, Will Moore, Frank Barney, Fred Hatch, and M. McGraw; (back row) Caroline Liebrooke, Mary Kennedy, Jennie Moore, Ella Filkius, Jennie Waupler, Julia Walz, Ida Pratt, and Bertie Grub. (Photo courtesy of BECHS.)

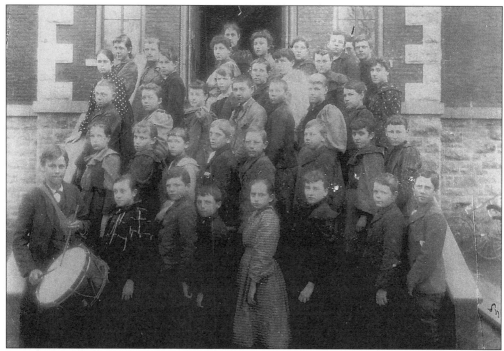

The sixth grade class at Pleasant Grove School posed in front of the school in 1892, accompanied by their own drummer boy, Garth Rice. (Photo courtesy of BECHS.)

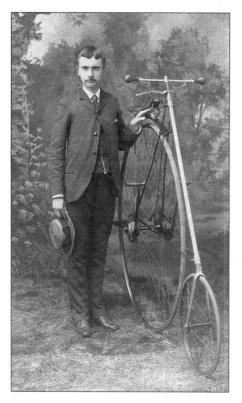

Mr. J. Hub purchased this Star bicycle in 1884 and used it to travel to and from work in Mankato. Some of the other Mankatoans who owned bicycles at this time were A.G. Lewis, Martin Walser, George M. Palmer, Dick Rose, W.D. Willard, George T. Barr, and Robert T. Bell. (Photo courtesy of BECHS.)

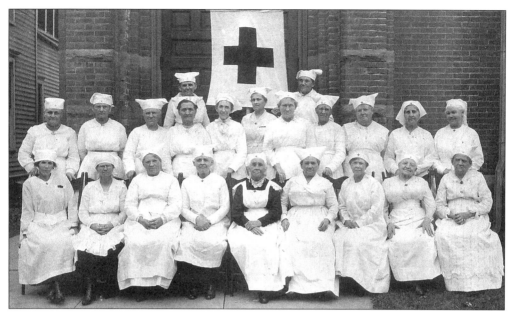

In 1918, these members of the Welsh Presbyterian Church located on State Street served as Red Cross volunteers. Many had sons serving overseas in the American Expeditionary Force. Pictured, from left to right, are as follows: (front row) Mrs. Geo. Anderson, Mrs. Dora Jones, Mrs. Peter Lloyd, Mrs. Hugh (Mary) Jones, Mrs. John Pugh, Mrs. Lake, Mrs. Isaac Griffiths, Mrs. John Edward, and Mrs. Sarah Richards; (middle row) Mrs. Humphrey Roberts, Mrs. Wm. Wigley, Mrs. Robert Jones, Mrs. Ed H. Jones, Miss Jane Lloyd, Mrs. W.E. (Reverend) Evans, Mrs. John Davis, Mrs. Wood, Mrs. Henry James, Mrs. John Evans, and Mrs. Bennett Williams; (back row) Mrs. John Hughes and Mrs. Peter Roberts. (Photo courtesy of BECHS.)

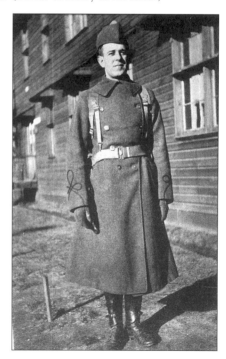

Lieutenant Leslie Morse is pictured in his World War I coat and uniform, c. 1917. Leslie Morse, a Mankato lawyer, later served as Municipal Judge for 40 years. (Photo courtesy of BECHS.)

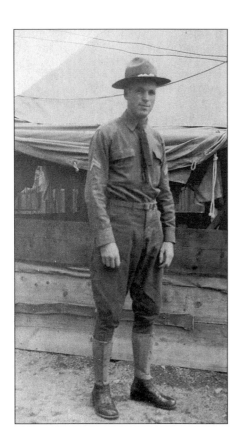

Luther Matthews, son of H.C. Matthews of Mankato, dressed in his World War I uniform in front of a camp tent. (Photo courtesy of BECHS.)

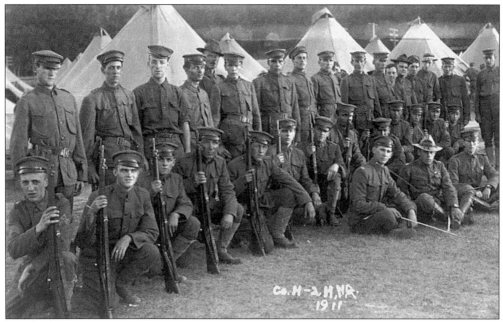

This was an encampment of Company H, 2nd Minnesota Home Guard in 1911. (Photo courtesy of BECHS.)

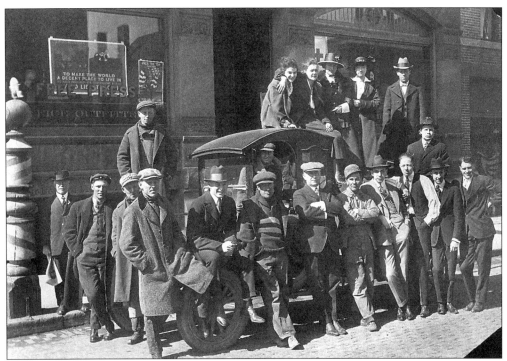
The *Free Press* newspaper force posed in front of the company building in 1917. The patriotic posters refer to American involvement in World War I. (Photo courtesy of BECHS.)

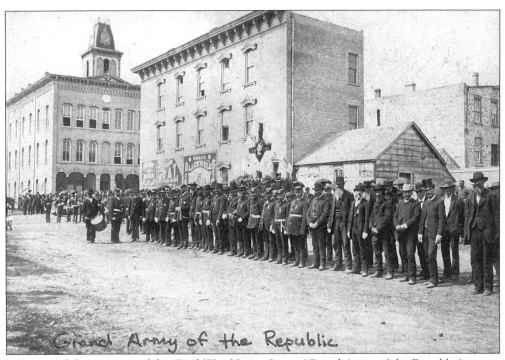
Meetings of the veterans of the Civil War Union forces (Grand Army of the Republic) were a frequent sight at the end of the 1880s. (Photo courtesy of BECHS.)

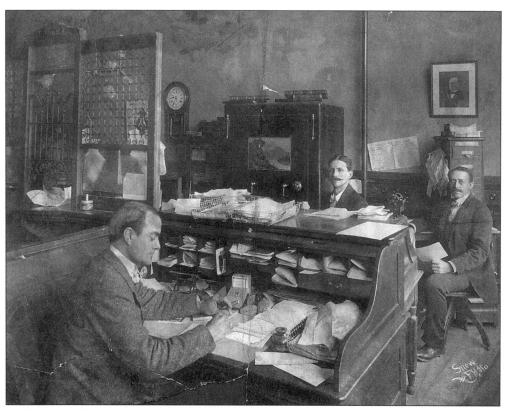

Pictured here are the Officers of the Mankato *Free Press*, c. 1904–1905; from left to right, are as follows: L.P. Hunt, president; Jay W. True, vice president; and Michael Fritz, treasurer. The *Free Press* Printing Company was located at 127 East Jackson Street. Although the *Free Press* celebrated its centennial in 1987, its beginnings actually go back to 1857 with the first issue of the *Independent*. (Photo courtesy of BECHS.)

Otto Malchow stands on the brick cobbled pavement of Front Street in early 1900. In the background on the left is the railroad freight station and on the right the J.I. Case Implement building with the Case eagle on top. The tall smokestack in the rear is the Hubbard Mill. (Photo courtesy of Frank Wilkins.)

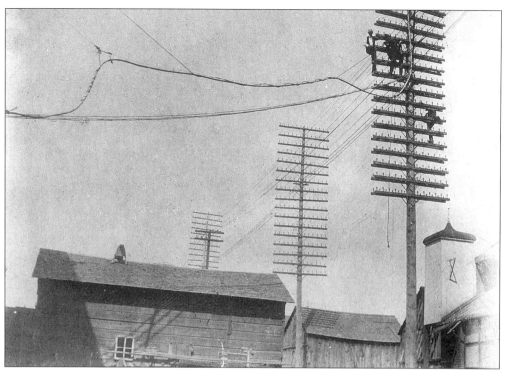

Mankato Citizen's Telephone Company lineman string wire and check connections on a city pole. Each phone service had its own wire in 1899. (Photo courtesy of BECHS.)

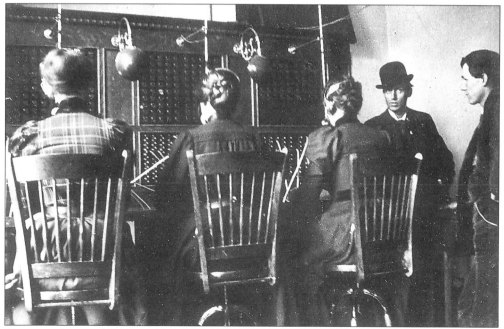

This was the Mankato switchboard in operation in 1899. Pictured, from left to right, are as follows: Kitty Carroll; Sibyl Jewson; Mrs. Mason Hynson; Mr. Kellogg, contractor; and Mr. C.K. Willard, manager. (Photo courtesy of BECHS.)

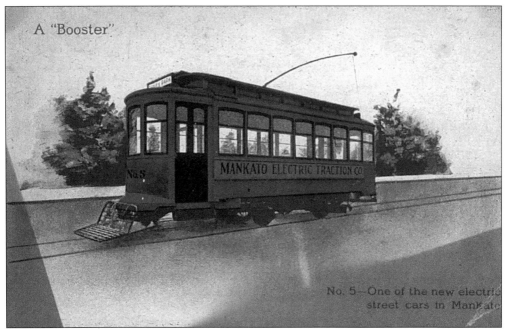

Street Car #5 was one of the new electric street cars in Mankato about 1908. The company was called the Mankato Electric Traction Company. The street cars were about 30-feet long and ran in both directions with motors in both ends. They had two wheels at each end, had a single-wire trolley, and could comfortably seat 30 passengers. The company operated until 1930 when bankruptcy closed the line. (Photo courtesy of Agnes Sellers.)

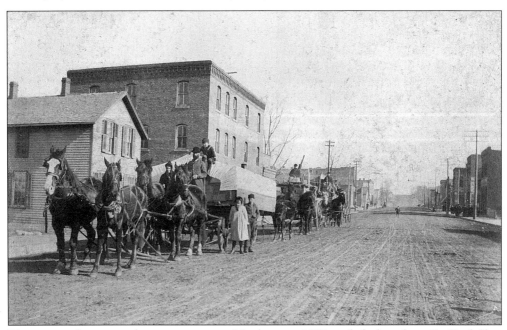

There were three stage lines operating in Mankato in 1857: a daily line from St. Paul (fare $7.00), a tri-weekly line from Blue Earth (fare $4.00), and a tri-weekly line from Owatonna (fare $5.00). (Photo courtesy of BECHS.)

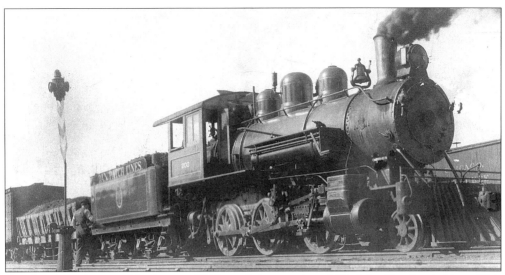

A railroad employee at Mankato, c. 1900, tends locomotive #200 of the Dan Patch Lines. This line connected Shakopee and Mankato. The train was so named because it made weekly trips to the stable and grounds of the famous race horse Dan Patch at Savage, MN. (Photo courtesy of BECHS.)

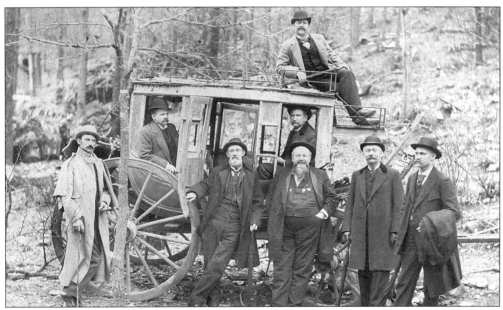

The period when stagecoaches were important to the transportation of the area extended from 1854–1870. By the 1870s, the railroad was stretching its line of steel through Blue Earth County and the days of the prosperity of the stage lines were numbered. After the coming of the railroad, the stage line still served the outlying areas, which the railroads couldn't serve. The stagecoach also carried passengers to and from the railroad depots. This photograph of a group of Mankato businessmen posed in front of the Concord stagecoach was taken c. 1890. Pictured, from left to right, are as follows: unidentified, General James H. Baker, John F. Meagher, Lester Patterson, and Professor Newell. The two men in the coach are unidentified and the man sitting on top of the coach is A. Longini. (Photo courtesy of BECHS.)

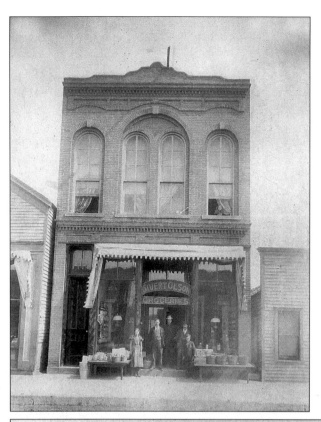

Sivert Olson stands at the door of his grocery store with Ole Hanson and three other unidentified people, c. 1895. A young lady peers out the window of the second floor of the building at 225 North Front Street. (Photo courtesy of BECHS.)

These workers take a short break at the Korshus and Nostdahl Brothers factory in Mankato, c. 1895. This factory manufactured furniture, building fixtures and woodwork. (Photo courtesy of BECHS.)

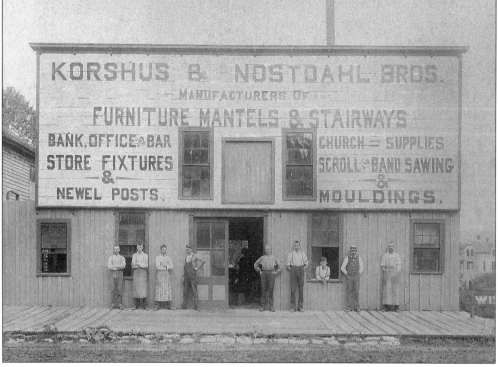

Martha A. Brandt Millinery staff, c. 1902, proprietors of the "Miss Martha Brandt, Fine Millinery," opened shop in 1898 at 107 North Front Street in Mankato. She spent 43 years as a milliner. (Photo courtesy of BECHS.)

Modeling their fancy creations, from left to right, are as follows: (front row) Lydia Emmel and Martha Brandt, milliner; (back row) Bertha (Brandt) Emmel and Minnie Emmel. (Photo courtesy of BECHS.)

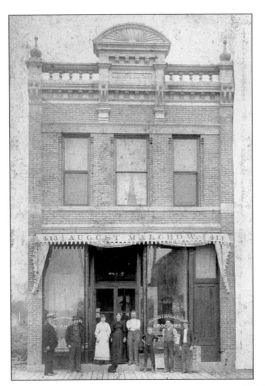

The Malchow family stand in the doorway of their grocery store at 413 North Front Street, c. 1890. Pictured in the doorway, from left to right, are as follows: Lydia, Ernestine, and August C. Malchow. The others are unidentified. (Photo courtesy of Frank Wilkins.)

Bicycles were an important form of transportation. Alvin Laird of LeHillier was 15 years old in 1892 and often rode his bicycle across the bridge over the Blue Earth River to Mankato. (Photo courtesy of BECHS.)

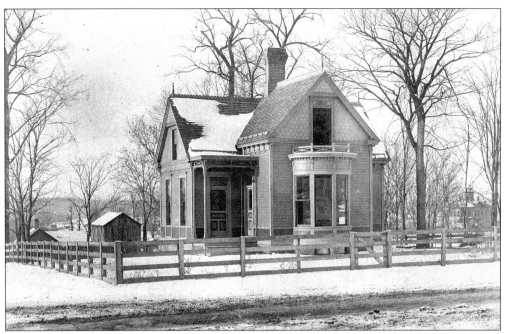
This cottage at the corner of North Sixth and Vine Streets in Mankato was built for the Albert Schippel family. Mr. Schippel was a Mankato architect. (Photo courtesy of BECHS.)

Pictured are the home and offices of Dr. J.W. Andrews at 510 South Second Street in Mankato. This photograph was taken in 1896 and shows the office entrance on 125 East Cherry Street. Later, Dr. Andrew's son Roy became a doctor and practiced medicine with him at this office. (Photo courtesy of BECHS.)

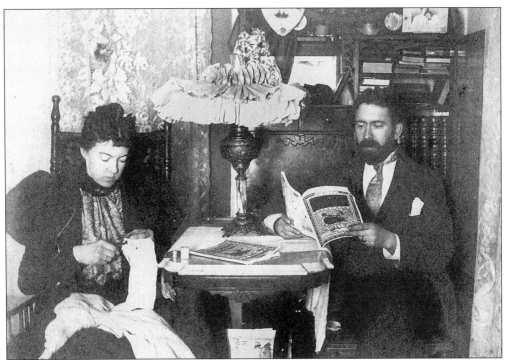

Edward and Lizzie Jones relax at home (328 State Street) in Mankato, c. 1894. Mr. Jones managed the local Western Union Telegraph office. Edward and Lizzie Jones had three daughters: Florence, Grace, and Edna. (Photo courtesy of BECHS.)

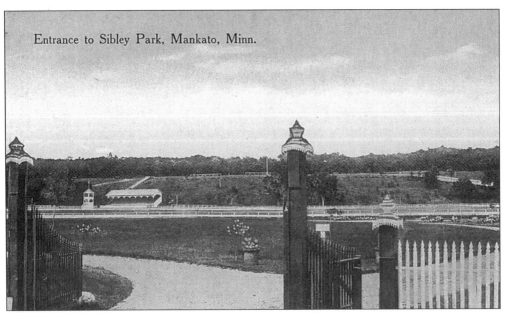

The old entrance to Sibley Park was a wooden gate and fence. Note the race track and grandstand in the background. The race track was built about 1887–88 and remodeled in 1893. The world famous race horse Dan Patch raced at the Sibley Park race track many times. (Photo courtesy of BECHS.)

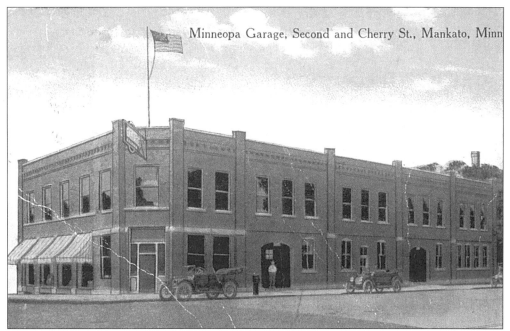

The Minneopa Garage, at the corner of Second and Cherry Streets, was built by G.A. Lewis for Reo, Cadillac, and Apperson cars. The service station and garage accommodated 100 cars. Today, the building is occupied by the Earl Johnson Furniture Store. (Photo courtesy of BECHS.)

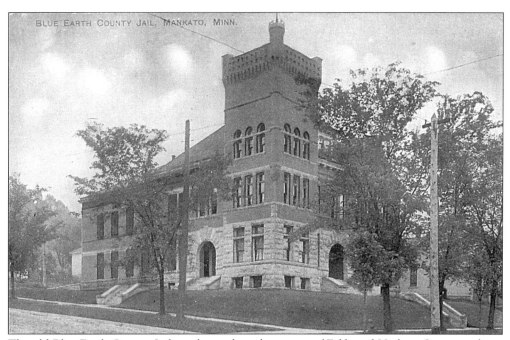

The old Blue Earth County Jail was located on the corner of Fifth and Hickory Streets and was built in 1895 for $28,000. This building was later demolished. (Photo courtesy of BECHS.)

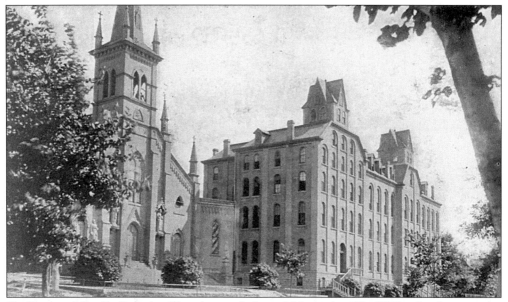

St. Peter and Paul's Catholic Church was dedicated November 23, 1873, after being under construction for three or four years. The school opened September 4, 1876. (Photo courtesy of BECHS.)

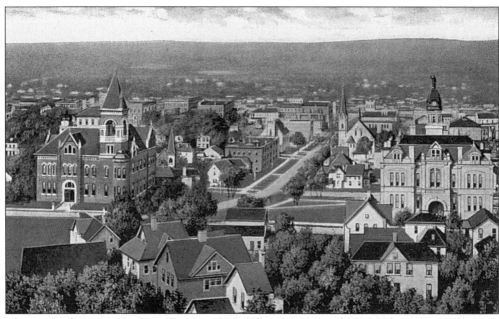

This is a bird's eye view of Mankato, c. 1920. (Photo courtesy of BECHS.)

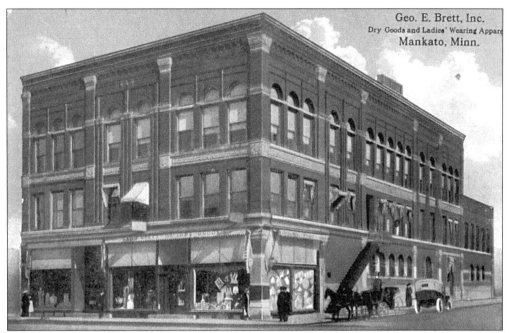

A fixture in merchandising of dry goods and ladies wearing apparel for over 100 years, the George E. Brett Company was founded in 1868. Located at the corner of South Front and Cherry Streets, today the building is enclosed in the downtown mall. George Brett married Lizzie Maxfield in 1873 and they had three children: James Edwin, Frank, and Mary. (Photo courtesy of BECHS.)

The Taylor and Hotaling Hardware store on South Front Street, pictured here c. 1862, opened in Mankato about 1858. Note the building construction and the bracing pole on the side. (Photo courtesy of BECHS.)

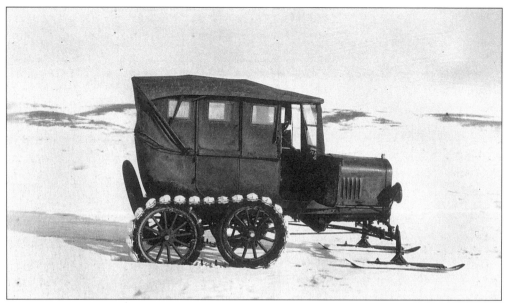

This photo of an early "snowmobile" was taken about 1915 in Mankato. It was a "convertible" idea. Note the runners in front and the traction tread in the rear. (Photo courtesy of Kathleen Cain.)

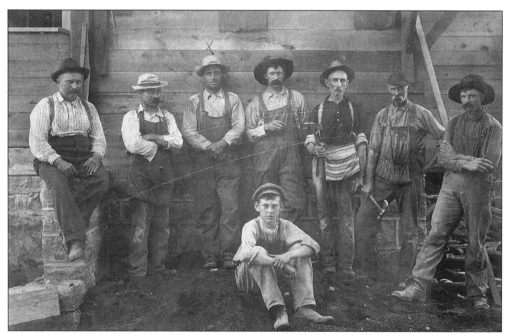

Mankato carpenters take a break from their work and pose for this photo taken in the late 1800s. All are unidentified except Rudolph Rosenau, the third man from the left. During Mankato's early years, carpenters were in demand, not only for housing but for making wagons, carriages, furniture, and barrels. (Photo courtesy of BECHS.)

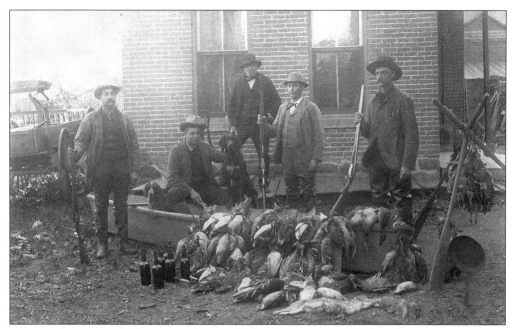

Five area hunters with their guns, dogs, and a bottle apiece pose by their boat with game birds and rabbits. A tripod made of oars holds additional evidence of their successful hunting trip, c. 1895. Pictured, from left to right, are as follows: unidentified, John Lang, Henry Boegen Sr., Henry Dreher, and John Theissen. (Photo courtesy of BECHS.)

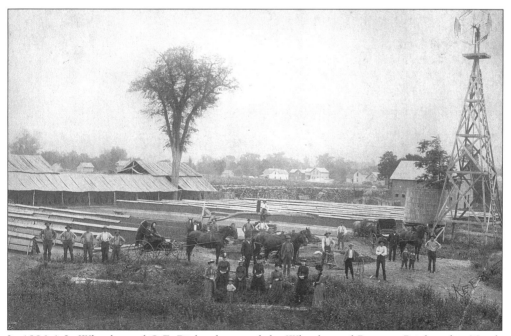

In 1886 A.L. Wheeler and O.E. Richards started the Wheeler and Bennett Brickyard in North Mankato on the site of what is now Wheeler Park. They began turning out 16,000 bricks a year and nine years later made 8,000,000. This photo is an early photo of the brickyard, c. 1895. (Photo courtesy of BECHS.)

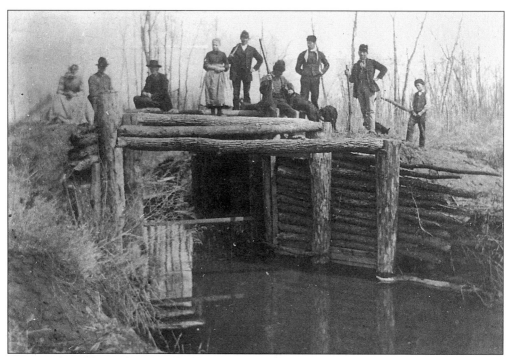
Spring Lake at the outlet of Mud Lake in North Mankato. (Photo courtesy of BECHS.)

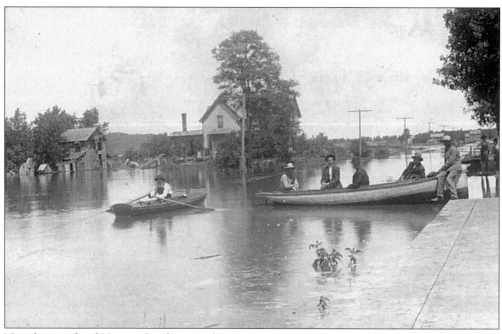
Not the canals of Venice, but boating for transportation on Range Street in North Mankato during the flood of June 1908. Waters weren't so calm at mud lake flats where a resident was rescued by boat. (Photo courtesy of BECHS.)

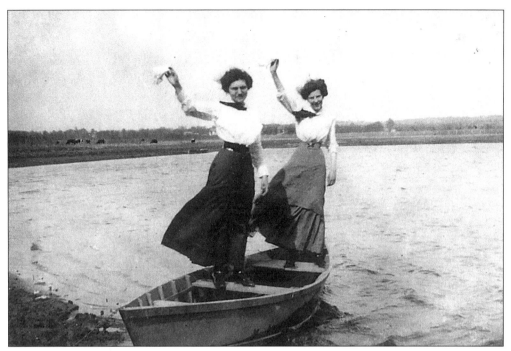

Genevieve Hodapp and Marjorie Johnson are all set to go boating on Spring Lake. (Photo courtesy of Tom Hagen.)

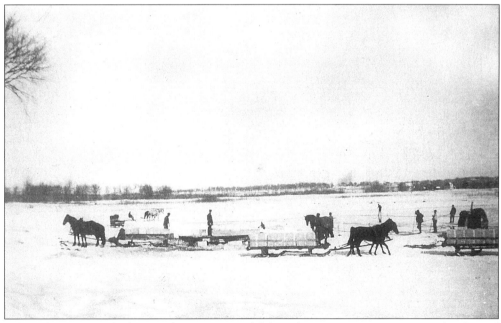

When the ice was thick enough on rivers and lakes, the ice companies cut out chunks and stored them in sawdust in large ice houses. In the summer, the ice was cleaned and delivered to the kitchen or back-porch ice boxes of residents. This scene is on Spring Lake. (Photo courtesy of BECHS.)

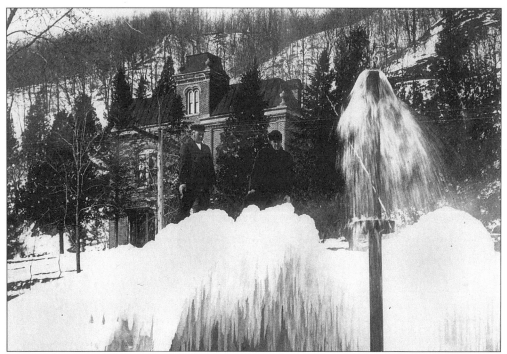

Wendell Hodapp (1842–1920) is shown in front of his home on Lake Street in North Mankato. The man on the right is unidentified. Wendell Hodapp, a Mankato druggist, had a drug store at 302 North Front Street in the mid-1800s. Note the artesian well in the winter. (Photo courtesy of Tom Hagen.)

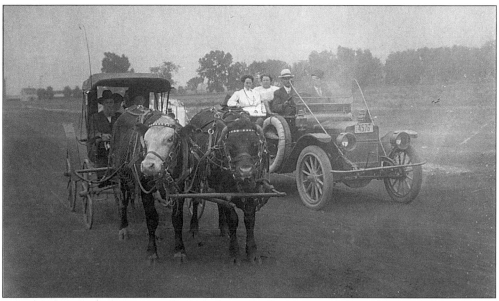

Mr. and Mrs. Oscar Bennett and Mr. and Mrs. William Stewart dressed as "Past and Present" for the 1912 Mankato Fair. Both men operated brickyards in North Mankato. Many brick homes in Mankato and North Mankato were constructed from these early brickyards. (Photo courtesy of BECHS.)